No. 2251
$8.95

HOW TO TAKE GREAT PHOTOS FROM AIRPLANES

BY FRANK KINGSTON SMITH

MODERN AVIATION SERIES

TAB BOOKS

BLUE RIDGE SUMMIT, PA. 17214

cop. 1
Ref.

FIRST EDITION

FIRST PRINTING—FEBRUARY 1979

Copyright © 1979 by TAB BOOKS

Printed in the United States of America

Library of Congress Cataloging in Publication Data

Smith, Frank Kingston.
 How to take great photos from airplanes.

 Includes index.
 1. Photography, Aerial. I. Title.
TR810.S54 778.3'5 78-13619
ISBN 0-8306-9879-5
ISBN 0-8306-2251-9 pbk.

FOREWORD

This is not a book for professional photographers, nor is it for experienced semi-pros. It is written for people who fly—and take pictures—for fun. After more than twenty years of learning by trial and disappointment, I have scribbled about some things I wish someone had told me when I was getting started. My hope is that no weekend pilot who reads these pages will ever again set off on a flight, whether it be local or cross country, without a camera always handy, loaded and *used*. The dividends are priceless.

Happy flying—and Happy Memories!

Frank Kingston Smith

Contents

Chapter 1
About Aerial Photography

"Aerial photography!"—the very term reeks with romance, conjuring up images of exotic cameras the size of trash cans, bearing porthole-sized lenses, poking like glinting eyes from holes cut into the bellies of specially designed or modified aircraft prepared to fly so high that they are invisible from the ground. One cannot help thinking about military uses and visualizing photo-interpreters evaluating potential targets or assessing bomb damage, although peaceful uses of aerial photography are becoming better known too: photogrammetry for mapping, flood control, forestry and land use planning. For these precision uses, there are two types of aerial photographic technique: vertical photography and oblique—straight down and off-to-the side. Most are taken straight down from a precise altitude above the ground, so that the results will be of the same scale when joined together to form a mosaic, a large photograph covering hundreds of square miles. Some aerial photographs are taken out towards the sides of the airplane's path, but scale analysis of sidelong glances from aloft requires a computer to achieve accurate results for technical photographic missions.

However, this essay has nothing to do with the arcane aspects of scientific aerial photography, nor is it concerned with the artistic uses of commercial aerial photography which involve photographic composition to tell a story, although examples will be used to illustrate some of the fine points of technique. What we are interested in for the most part is simply capturing on film some of those otherwise fleeting memories of enjoyable flights in your airplane, when the sun

is bright and the skies are clear. It concerns taking pictures of your own home and your own neighborhood, as well as the sensational vista of the towering spires of downtown Chicago, seen while on an approach to Meigs Field, or of Miami's "Gold Coast," of the big bend of the Mississippi River at New Orleans, of Cape Cod, small islands off the coastline, the Rocky Mountains, or of your own airport, and others you have visited. Once in a while, you may be able to snap a picture of the sight reserved for airmen: the Pilot's Rainbow—a complete circle with the shadow of your own airplane sharply defined in its very center. We have a photo of our plane in the center of two concentric circular rainbows. Most of our air-shots are worth more to us than money, because when we show them on a large glass-bead reflector screen, as long as the colorful image is there, so are we, for a few moments.

The important fact is that few (perhaps none) of my airborne shots are of professional quality. If any come off with breathtaking results, it was because of sheer luck, and I frankly don't care whether or not they are salable to a magazine. I take them for my own memory aids, not for approval of an editor. An impulsive shot taken from the window as you whiz past Miami, or a photo of your own neighborhood doesn't have to be a work of art to be enjoyed. You don't have to be another Stiechen or Karsh. In the beginning, it is satisfying to poke the camera at any object that catches your fancy and take a picture of it. We used to call such pictures "snap-shots" without being embarrassed to use the term; now, the same technique, especially when applied to 35mm cameras, is dignified by using the term "grab shots," but they are still nothing more than snapshots, only taken from another angle when made from an airplane. That will be the way you will start, as we all do. Perhaps, some day you will become so interested that you will learn enough to have your air shots pass muster by a highly critical editor.

After a while, most people who have taken pictures from the air begin to wonder how professionals produce the wonderful pictures from aircraft that appear in the slick magazines and particularly in *National Geographic Magazine*. Many articles and books have been written on the subject, but, like books and magazine articles on the art of flying, they tend to be so elementary as to insult one's intelligence or as complicated as texts on astronomy or nuclear physics. The premise here is that although the literature of photography sometimes seems to make having a graduate degree a prerequisite to engage in the activity, you don't have to be a chemist or an expert in optical physics to take good pictures from a plane any more than you have to be an aeronautical or petroleum engineer to

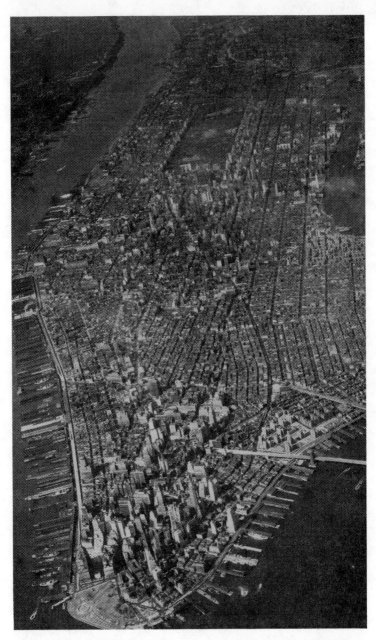

Manhattan Island from 10,000 feet due east of Newark airport, looking north up the Hudson River. On one of those once-a-year days when a cold front passage whips through and cleans out all the air pollution. Taken with a normal lens, no filter. Slightly underexposed, then overdeveloped. This picture has been enlarged to 17 × 22 inches for display. (Tony Linck photo)

fly an airplane in the first place. However, it does help to have at least a superficial understanding of some of the principles of photography, if for no other reason than to be able to read the photographic magazines on the newsstands with a degree of comprehension. As in the parallel situation of aviation magazines, a layman becomes instantly confused when he butts his eyeballs up against terms that we, who are already involved, take for granted and understand perfectly. Like flying, photography has a lingo all its own, hence much of the material already in print is as foreign as Sanskrit to the casual reader.

My purpose here is to explain the subject simply enough that, before anyone goes out and blows a wad of money to acquire more exotic equipment than he needs for his first foray into aerial photography, he can understand enough about it to make a reasonably informed judgment concerning what type of equipment will produce the results he wants.

Be advised that aerial photography, like flying, is fascinating and that the more you get into it, the more fun it tends to be. As in the case of boat owners and airplane owners, once you begin to feel at home with your initial equipment, you will be looking for something that will do the job a little better, a little easier, a little faster. Oh hell, we've all been there!

This book is sort of a ground school course for a new phase of flying which you may wish you had started sooner.

Chapter 2
Getting Started

An old Pennsylvania Dutch recipe for Massenfeffer begins, "First, you catch a rabbit..." Obviously, if you are going to take aerial photographs, first you catch a camera. It does not have to be a camera to be used *exclusively* for aerial photography; indeed, it should be used for all sorts of photography, but many cameras that are excellent for shooting the family and friends posed on the back stoop are not necessarily good for all-around air work. What kind of camera is suited, and why, including a analysis of film sizes, lenses and associated equipment, is the first step—including a comparison of their costs.

CAMERAS, GENERALLY

Perhaps you already have a camera of some sort, used for taking snapshots, not an expensive or complicated camera, but one of the easy-loader, point-and-shoot types, perhaps an ancient Brownie or a modern Instamatic by Kodak or similar so-called "110" cameras by Argus, Fuji, GAF, Minolta, Rollei, *et. al.* Perhaps you have a self-developing outfit, the "instant picture" system of Polaroid, Keystone or Kodak. Or, it might be a 35mm camera or a 120 roll film type. If so, take whatever you have up on your next hop, shoot a few pictures and see how they come out. If your present camera produces satisfactory results as far as you are concerned, stick with it. If, on the other hand, you conclude that it is too large and bulky to handle in the plane or that it does not yield the quality of aerial photos you want, you can't help wondering what will do the job

better. Once those first 3 × 5 so-called prints (they are really enlargements) come back to you it probably will not take long to realize that the camera on hand is not entirely suitable for the purpose and the decision must be made whether to obtain another. Usually, this is where one comes to grips with basic decisions of type, size and cost. The first step, the one you take through the door of the camera store, often leads to utter confusion, not unlike that of a small child's first visit to a candy store.

Because of the increasing popularity of photography as a hobby, most camera stores carry a bewildering inventory of equipment, not only cameras but lens assortments, filters, films and accessories. Films, for example run from 35mm half frames, about half the size of a postage stamp, to some as large as 4 × 5 inches. With a wide variety of sizes between—and in some cases, beyond—those parameters.

THE MOST WIDELY USED FILM SIZES

Two film sizes dominate the retail market and are by far the most heavily used. A film known as "120 size" produces negatives 2¼ inches square, giving about five square inches of film area to work with. Translating these dimensions to millimeters for the purpose of making comparisons, they are about 60mm on each side of the square format negative and cover 3600 square millimeters. A roll of 120 film, whether in black and white or in color, and they come in both versions, contains twelve exposures; another version, known as "220" by changing the wrapping technique of the film roll, will double that to 24 exposures.

The film size with the widest applicability is the 35mm, supplied in small cassettes of either 20 or 36 exposures. Available in a broad assortment of film speeds, B&W and color types, they produce negatives of approximately 25 × 34mm (or 1 × 1 1/3 inches). Their 850 square millimeter area is slightly less than one quarter of the 120/220 film mentioned above. As far as non-professionals are concerned, it is academic. Either size will produce excellent results.

FILM TERMINOLOGY

As soon as he becomes exposed to photographic terminology relating to film, especially to references to such things as "ortho-chromatic" film, "ortho-panchromatic" film, panchromatic, super panchromatic, color negative, color reversal, professional pan, in-frared, indoor color, outdoor color, it is little wonder that a new-

comer's head spins. No one seems to realize that beginners have no comprehension that certain lenses and filters and films, such as infrared film, are not for them, but are used by professionals and are reserved for special uses. Every beginner is totally confused about what is meant by "fast" films and "slow" films, and "fast" vs. "slow" lenses, and not all photographers understand the differences between "fine grain" film and "coarse grain" film, and high contrast film, particularly when in common parlance in our everyday lives "fast" means "best" and "fine" means "expensive." Really, there is no reason to put stress on the technological side of photography, but just as in aviation, we all tend to speak in our own peculiar language, as do doctors, lawyers, computer people, and, I guess, just about everyone working in a special group. First, let's clean out some underbrush.

ABOUT POCKET CAMERAS

Pocket cameras were developed for the specific purpose of making snapshot photography available for the mass market; the cameras are impossible to load incorrectly; some will lie down and refuse to work if the light is not adequate to take a picture, others will shine red lights or otherwise signal when a picture cannot be made. They will produce 3¼ × 4¼ "prints" in either black and white or in color. Most of them have one or two shutter speeds; some have aperture selectors of two sizes, which make them great for the purpose intended: taking pictures at the beach or in the yard. But the shutter speeds are not fast enough to freeze action, so they are affected by the motion of an aircraft, particularly the vibration of the engine and propeller and, worst of all, as far as air shots are concerned, they have wide angle lenses which produce unsatisfactory results because details are lost, much as when looking through the wrong end of a telescope. Their wide angle lenses, designed for use at close quarters, do not produce the sharpness for enlarging objects at least a fifth of a mile away, from an altitude of 1,000 feet.

This is not to put the knock on the simple-to-operate cameras which are eminently suitable for the uses their designers intended: to take close-up group pictures for the family album. Indeed, it is recommended that at least one such camera be carried at all times when travelling, to take pictures of preflight preparations and to help document the memories of the trip itself: who was along, where they went and what they did. But neither the lenses nor shutter speeds are really qualified for aerial photography. So let's not waste them on that kind of shooting.

THE ALTERNATIVES

Cameras for air shots are bound to cost more than the $25 to $50 range of most pocket compacts made for the volume sales market. On the other hand, this does not mean that aerial cameras for the non-professional photographer have to put a permanent crimp in the family budget. What most of us want is a reasonably small, versatile camera with a system of such quality that the end result will be clear and sharp under enlargement, either on a projection screen or on enlarging paper. It is also recommended that a camera be selected with an eye to film availability, no matter how far afield we range on a trip, from northern Canada to the Caribbean and Central and South America. Putting all of these criteria together, we narrow the field to two choices: the 2¼ square format and the 35mm line.

FILM SIZES

Two-and-a-quarter film comes in either 120 or 220 rolls; both in black and white and color film, with the color film having another choice, transparencies or color slides. The 120 film produces 12 negatives (or transparencies) to a roll; the 220 yields 24. The color prints (actually, they are 3 × 5 enlargements) normally received from the processing laboratory may be mounted in albums, just as black and white pictures; in addition, the ones you like most may be enlarged, framed and hung on the wall.

Most widely used are the 35mm cameras and films, hence one has a wider choice of film characteristics, both in color and black and white, and like Hershey bars, the film is sold almost everywhere in the world. The 35mm films will do just about anything that the 2¼ × 2¼ films will: their color prints (enlargements) look the same when they come back from the lab; their transparencies are carried in the same size carriers and project about the same and working with them in one's own darkroom requires virtually identical techniques. Only one factor differentiates them: the sizes of the cameras involved.

Old cameras, those of 30 years ago, had Brownie-like prism viewfinders; sometimes flip-up wire viewfinders were used on press photographers' equipment, like World War I machine gun sights. The Speed Graphic "press" camera was a (if not *the*) prime example of this, usually built to handle large sizes of cut film or film packs, up to 5 × 7 inches.

About 1920, a new development was introduced, the "reflex" camera, one of the first being the Speed Graphic. In this, there were

two lenses, one mounted above the other on the front of the camera; the image from the top-most lens was reflected by means of a mirror onto a ground glass located on the top of the camera, which had a folding shade attached so that the photographer could look down and see what he was photographing. Then, when he pressed the shutter release, the lowermost lens was used to expose the picture on the film.

Twin lens reflex cameras of the Graflex type were quite large, required two hands and the services of an assistant, particularly in the 5 × 7 size, although the somewhat smaller 4 × 5 was by no means a compact. Then from Germany came the 35mm cameras, the first true small sized cameras (they used to call them "candids" because of their concealability) and to meet the competition, camera designers reduced the size of the twins lens reflex (TLR) cameras by scaling down everything, including the size of the film they used. The 120 TLR caught on with professional photographers everywhere, for all kinds of work, from out of doors to photo studio sessions. They are particularly well liked for working in quiet surroundings (such as in church) for special jobs (such as wedding photography). Their strongest selling point apparently was that color and B&W retouching was easier on their slightly larger negatives. They are very fine, precision tools for any serious photographer, but have a couple of drawbacks for aerial work.

First, they are bulkier than most 35mm cameras, and as a result are not quite as handy in a cockpit. Second, the ground-glass view-finder feature is unuseable: to see the image, the photographer normally holds the camera chest high, looking down at the finder and for air-to-ground pictures this is impossible, since it would place the lens below the bottom of the window sill or glare panel of the airplane. To overcome this, TLRs have a modern version of the old wire gunsight viewfinder, a pop-up direct vision arrangement to help approximate what will be photographed.

For several years, I used a Rolleiflex 2¼ square TLR both for air to air and air to ground photography and got some wonderful results with it. As a matter of fact, I probably would still be using it to some degree, were it not for the fact that one day, on an air to air mission, I dropped it out of the airplane, thereby rendering it null and void.

The situation arose on a beautiful clear spring day while taking pictures from a Cessna 172 of other airplanes recently sold to customers of the Flying W Ranch, a Western style dude ranch for private flying, with which I was then associated. When a customer picked up his airplane, he received, along with the keys, a beautiful 8

X 10 color photograph of his new baby, suitable for hanging on the wall at home or at the office.

With four airplanes lined up for "sittings," waiting for a really clear day—a Comanche, an Apache, a Cessna 182 and a Swift—the sky finally cooperated, so we dragooned up a quartet of company pilots to fly them and prepared to go.

The preparation involved removing the right front door of the 172 camera plane. Why we did not simply remove the window is beyond me, or for that matter why we just didn't clean the windows, but I slung the Rolleiflex around my neck and off we went, my trousers, shirt and hair rippling in the breeze.

At 2,000 feet, with the noise and draft levels both at the threshold of pain (I hadn't thought about how *cold* it was going to be with all that wind blowing) we flew around and around the Flying W while the quartet of pilots formed up for the three-shots-per-client effort.

Sitting sideways in my seat, my feet dangling out into space, with the ridiculously inadequate seat belt loosely around my waist, I levelled my camera at the Comanche edging up from our right-rear quarter. Wanting to be sure that I was going to have the plane centered I watched the image on the ground glass grow larger as I beckoned the pilot closer with hand signals. He was no more than 100 feet away when I fired off the last exposure due plane No. one, and waved that I was finished with him. I had been doing so much twisting around that the camera's neck strap had been in the way, so I had unfastened it and stuck it under me on the seat while concentrating on the restricted field of view in the glass. When I looked up, my hair stood on end. While taking those first pictures, the other three airplanes had lined up on us in what the military calls a "high echelon right," completely in the Comanche pilot's blind spot, so that he didn't know they were there, nor did I. When I casually waved him off, the pilot pulled up into a steep right climbing turn directly in front of the other three planes! It would have made a spectacular photograph—even more if in a motion picture—for the formation broke up in a Blue Angel sunburst; thank God the other pilots were aerobatic professionals who reacted immediately to the Comanche's break-off. However, no matter what kind of a camera I might have had, I wouldn't have captured the scene on film; by the time I recovered from the shock of seeing the multiple near miss only yards away, the Rolleiflex was gone, buried somewhere in the muddy woods below. I never felt it go.

I had to go back up a few days later with a new camera and shoot the job all over again, one plane at a time. The new camera was a

little Retina IIIc 35mm camera, which had a 50mm lens and an interchangeable 80mm lens, semi-telescopic, as well. It was my first personal experience with longer-than-normal lenses and completely sold me on the 35mm size camera. It was smaller, handier, able to take 36 pictures instead of 12 (I never used the 220 version with the 24 exposures in the Rolleiflex). Since that time I have used 35mm cameras for my first line, including two Voightlanders, a Canon, a Topcon and my present Nikkormat.

RECOMMENDATION

I believe that the 35mm camera is well nigh perfect for use in a light airplane. It is small, lightweight, enormously versatile and produces quality photographs equal to all but the most expert eyes with cameras using slightly larger film sizes. The variety of selections of film available, both in black and white and in color is incredible and enlargements can be made to just about any size anyone might want. As for sharpness, all you need for proof is to look at the photographs in the *National Geographic* or some of the full page shots in LIFE Magazine reprints, virtually all of which were made with 35mm cameras.

As we will explore in Chapter VII, it is not necessary to purchase a new camera right away. Because 35mm photography is such a compelling hobby and the technology and product lines are being constantly upgraded, spurred on by competitive pressures, a brisk trade-in market puts many excellent used 35mm cameras on the shelves of most good photographic emporia, so that if you make your requirements known to a reputable dealer in your community, where if you are treated well, you will continue to do business, it is possible to start off with an excellent "pre-owned" (as they say in the automobile business) camera for a fraction of the cost of buying a new one.

Chapter 3
Basic Types Of 35mm Cameras

Generally speaking, 35mm cameras come in four categories:

(1) fully manual control;
(2) manually controlled with built-in light meters;
(3) semi-automatic, with "coupled" light meters;
(4) fully automatic.

These definable groups depend on the mechanisms built into the camera body and lens system, usually powered by one little electric cell no larger than three dimes piled atop one another. Let's take a look at them.

FULLY MANUAL CONTROL CAMERAS

To take a picture with a fully manual control camera, the photographer must (a) focus the camera; (b) set the lens opening or aperture; (c) set the shutter speed, (d) wind the film to the next exposure and (e) cock the shutter, before pressing the shutter release button to expose the film. The focus may be set on a scale on the lens, as guessed-at by the photographer, say, six feet, or eight feet; anything beyond 30 feet will be in focus if the distance setting is on "infinity," designated on the lens barrel by what in cow country is referred to as a "lazy 8," an "8" lying on its side, the mathematical symbol for "awaaaayy out there." Since all aerial photos are taken at distances beyond 30 feet, a lens will be focussed at infinity anyhow—and taped there, so it won't shift.

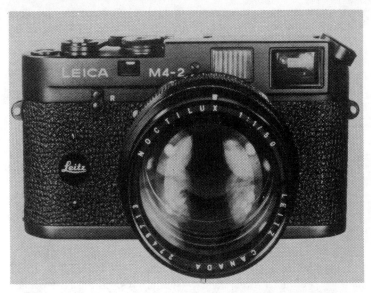

The classic Leica 35mm with a coupled rangefinder, a predecessor of the newer development known as the single lens reflex. Note that there are two "windows," one at each side of the lens (the center "window" is the light meter's face). As the photographer adjusts the focus, the double (split) image comes into sharp focus and the picture can be taken. The Leica is perhaps the oldest make of the 35mm camera industry.

There are two ways to set the correct exposure relationship of the aperture and the shutter speed. First, we have to discuss light meters as separate items.

A light meter contains a photo cell which measures the amount of light coming from (i.e. reflected by) whatever the meter's cell is pointed towards. On the meter a small needle registers this on a scale. Next to that scale a rotatable dial is located, on which a little opening is marked "ASA;" it is necessary to move the dial so that the "ASA" or rated film speed appears in the little opening, for whatever film you are using. For example, let us suppose that you are using Kodachrome 64 (Daylight) film. In the little cardboard box containing the film cassette you will also find a piece of printed material upon which is a wealth of technical information concerning the film it accompanies. Somewhere on that piece of paper it says, "Set the film speed on your...exposure meter at ASA 64 for proper exposure of its film." Having done so you match a needle marked "EV" (For "exposure value") and read on the rotating scale that at an EV of, say, 13, with the shutter speed set at 1/250th of a second ("250" on the camera markings) you must set the aperture at f/5.6 to make the correct exposure on the film. If you are flying under a brilliant sun

over clouds or snow covered ground, that would be the correct setting for the camera. You could set the shutter speed at 250, tape it, then set the aperture at f/5.6 and tape *it*, then leave the camera handy, already set and taped at infinity. When you want to take a picture, you need only pick the camera up, cock it, point it and press the shutter release. What you have done is made the camera into a point-and-shoot model.

There is not much to using a light meter, but some people think it is complicated. If you are bothered, let me say that you don't *need* a light meter, unless you are a purist or want to impress someone. Here's how.

The film manufacturers paid a *lot* of money to put all that material on the paper in the film box, so don't be embarrassed to use it to set your exposures, either on the ground or aloft.

On the face of the enclosure you will find a series of line drawings entitled, "Setting cameras without an exposure meter," for each film that is enclosed. In the Kodachrome 64 it says (a) "Set shutter speed at 1/125 second." Then it says, on the little comic strip, "(if the day is) bright or hazy sun on light sand or snow, set the aperture at f/16."

The next drawing says that for "bright or hazy sun, with distinct shadows" you should set the aperture at f/11. Then it goes on to tell you what to do when it is "cloudy bright (no shadows)," or under "heavy overcast," etc.

Note, the directions talk about settings at 1/125th, and we want to shoot at 1/250th. Now what? Easy: all you need to remember is that every time you move the shutter speed up or down one notch, a single click of the aperture setting the other direction will balance the exposure. If you move the shutter speed from 1/125 to 1/250 (one space on the setting ring), you need only move the aperture setting from f/11 to f/8 (one space on the f/stop setting). We will get further into this in a later chapter on Lenses and Lens Systems, so you can hold onto it for a while. It is enough to say right here that most of our aerial photography is done when the weather is at its best, under bright sunshine, so it is easy to keep the camera always loaded up with ASA 64 film with the settings taped at infinity; f/5.6 and 1/500th of a second.

MANUAL CONTROL WITH BUILT-IN LIGHT METER

The second camera classification is a step above the first in that the photographer does not have to carry a separate hand-held (or neck-slung) exposure meter with him. This development was made possible by the miniaturization of effective light meters; early met-

ers were about the size of a walkie-talkie and it was a triumph of science when they were made small enough to stick in a hip pocket. Now, they can fit into a compact camera body.

As might be expected, this made serious photography more convenient, although the photographer still had to set the exposure by hand after consulting the meter. It didn't do much either way for

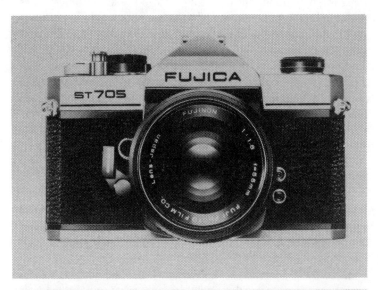

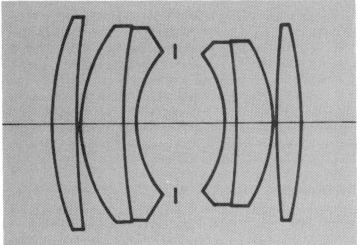

A Fujica single lens reflex camera with an f/1.8-55mm lens, together with a diagram of the arrangement of the six lens elements. In practice, all lens surfaces are coated with reflection-preventing chemicals.

taking pictures from airplanes, except that it indicated that camera equipment was becoming as complex as airplanes themselves.

Another early improvement was the optical focussing system to make photography easier. Older cameras, as many of today's less expensive drug store models, had a simple viewing port through which the camera operator could see approximately what he was going to photograph, but focussing, unless preset in the camera's design (as in the Brownie types) had to be set by hand after estimating the distance to the object being exposed on the film. The new system was built around a "range finder," consisting of two objective windows set a few inches—the width of the camera—apart with their images reflected into a single eyepiece in a split-image; when the focussing knob was moved, the image became a single sharp image, showing that the focus was right on the button. It was of great importance for close-up action pictures, but not required for aerial photography, since the focus is always set at infinity.

SEMI-AUTOMATIC CAMERAS

The third category of camera types, which are widely available at this time, were developed because many potential customers had declared openly that they could not understand directions about shutter speeds and aperture settings, but wanted easy to use, simple point-and-shoot cameras that would produce quality photos. To meet these ascertained requirements, camera designers came up with built-in gadgetry that made exposures automatic by connecting the built-in light meters with the exposure system, called "coupling" in photography parlance. The operator had only to set the light meter to the speed of the film being used (the ASA rating), in accordance with the directions on the little sheet of paper in the film box, and the camera would deliver the precise exposure.

Then, remembering the great public acceptance of the old twin lens reflex cameras which derived from the fact that the photographer could look into the viewfinder and see—the photographers' term is "compose"—what he was going to shoot, camera design engineers developed something better.

THE SINGLE LENS REFLEX CAMERA

Instead of having two "objective" lenses, one mounted above the other on the face of the camera, one for looking through to focus and compose the picture and the other to expose the image on the film as in the twin lens reflex cameras,—a situation which sometimes, because of a feature called "parallex," caused the decapitation of close-up subjects—single lens reflex (SLR) cameras were de-

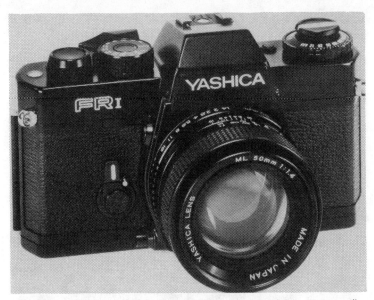

The Yashica single lens reflex series of cameras is one of the most versatile available, for they can use the entire line of interchangeable Yashica and Zeiss/contax lenses from the 15mm ultra-wide angle to the 1,000 super tele-photo types. One of the finest tools of the profession.

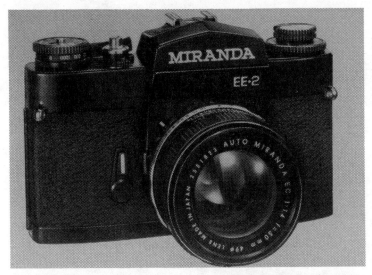

The Miranda EE-2 is an example of a single lens reflex semi-automatic camera with a built-in "coupled" light meter. First, you set the ASA on the light meter, then set the shutter speed and put the aperature (diaphragm) control on "auto" and the exposure is perfectly set, automatically. There is also an override provision for the automatic feature. The EE-2 takes all Soligor and Miranda interchange-able lenses.

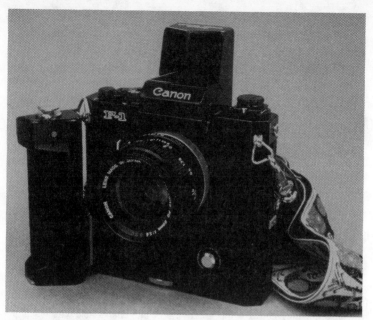

A Canon 35mm SLR with a motor drive attachment on the lower part of the camera body. A "robot" camera of high quality for those who need them.

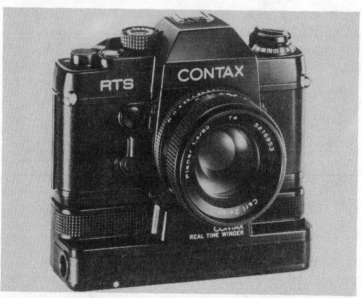

The classic contax RTS with a self-winder pack screwed on the bottom of its body. This camera is produced by Carl Zeiss of West Germany in cooperation with Yashica of Japan. The winder will expose two frames a second with continuous operation, if desired, for a series of photos.

signed so that the photographer could see, by means of an internal mirror system, through the actual lens of the camera. By its cunning device, the photographer can see exactly what will appear on the film when it is developed. All the mechanism in a SLR camera is spring loaded; releasing the shutter results in (a) the instant retraction of the image-reflecting mirror and (b) the opening and closing of the shutter, hence the characteristic "ka-thunk" as the film is exposed. SLR cameras are by far the most popular of the 35mm camera lines which are physically larger than the so-called compact 35s. As you read on, you will understand why compact 35s are really suited only for special aerial use, because of the limitations inherent in wide angle lenses for general purpose shots from aloft.

THE ULTIMATE FULLY AUTOMATIC CAMERA

With the prefatory note that the fully automatic camera is not required for aerial, or for that matter any photography of the type most laymen engage in, we should at least mention it in passing.

A fully-automatic, self-cocking, automatic exposure setting camera with automatic film transfer and the magazine capacity to hold enough film to make 250 exposures without reloading, is some-

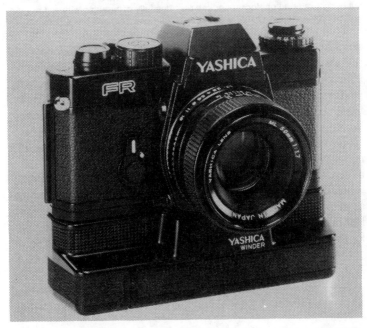

Another self-winder, the Yashica FR, with its winder in place. This is essentially the same camera as the Yashica FR-I a couple of pages back.

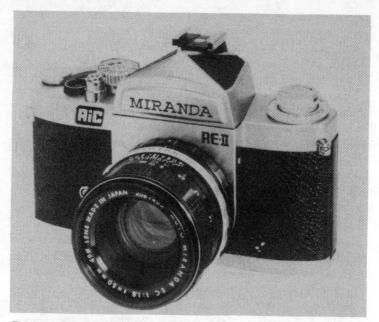

The 35mm Miranda RE-II single lens reflex camera is one of the finest a serious but budget-minded photographer can buy. It is fully compatible with all Miranda and Soligor lenses. An excellent all-around camera. This one has a 50mm lens.

times known as a "robot camera." The term might make one think that this would be the ultimate for a layman's use. Far from it: it is the epitome of complexity, useful only to professional photographers who are expert in every aspect of the art. Robot cameras are really basic SLR bodies with all sorts of attachments clamped on; they can be fitted with interchangeable lenses from 6mm focal length "fisheyes" to 1,500mm focal length super-telephotos, can be remotely mounted and remotely controlled and can fire off three shots a second from the huge spools of film, as long as the shutter release is held down, for almost a minute and a half. For special events such as auto races, steeplechases, football and baseball action, rocket launches and the like, they are extremely useful to professionals, but for the purposes of this book, can be disregarded. For a casual aerial photographer, using a robot camera would be like using a sledgehammer to drive a tack.

Chapter 4
About Lenses and Lens Systems

Up to now, we have been discussing cameras generally and camera body types, with passing reference to lenses and their associated mechanisms, yet more misunderstandings arise about this than anything else in photography. Mark Twain once said that he was not concerned about what people did not know; what bothered him was what they knew that was *wrong*. Because of the inherent ambiguities of the English language, certain terms (lawyers define them as "words of art;" most people call them "lingo") used in photography have an entirely different connotation to people who are not yet attuned to them. Other terms are simply not understood at all, yet are easily understandable if explained. Let's start with the basics.

A LENS SYSTEM

A camera's "lens system" consists of three parts:

1. The Lens itself; ·
2. An adjustable opening, or aperture, and
3. A shutter, adjustable to open and shut at precise speeds.

These three parts are interrelated in function to produce a sharp, correctly exposed image on the film when it is processed chemically. Hence, the three parts form a "system" and must be considered as such.

THE LENS

A modern high quality 35mm camera lens is not just a chunk of glass, ground to shape, like a magnifying glass. It is a complex of

several pieces of optical glass—as few as four, as many as 12—called "elements," all intricately ground, then precisely and scientifically coated with a thin layer of an optical-effective chemical. When mounted as a unit in a metal ring, they are referred to simply as the lens; because of the chemical coating, they are referred to as "coated" lenses.

If you examine the external surfaces (usually it will be the front surface, although the rear surface, inside the camera may also be viewed) of a good lens in bright daylight, you will see, if you hold the lens at just the correct angle, a purple film that looks like the sheen of oil on water. You cannot see this if you look straight through the lens, but it is the coating referred to above and it is in itself an important part of the lens' optical structure. This chemical coating, only a millionth of an inch thick, has the property of reducing the reflective quality of the glass by almost eliminating reflections; it allows more light to pass through and effectively increases the "speed" of the lens. To put it another way, it acts to make the lens optically larger because it gathers more light at the focal point, the film plane. In addition, the internal coating of the elements with the same chemical eliminates internal reflections and refractions which, before this coating was discovered, resulted in film conditions called flares, hot-spots or sun dogs.

ABOUT "FAST" LENSES

There has always been a certain amount of confusion about the term "fast" in photography: one hears about "fast" lenses, "fast"

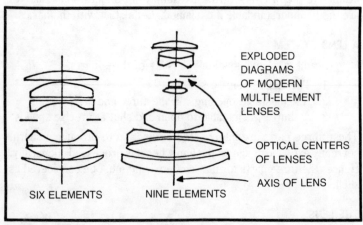

Examples of modern multi-element lenses to achieve clear, sharp photographs with 35mm cameras. The six-element lens here is a 50mm lens; the nine-element lens is a wide angle (28mm) lens.

shutters and "fast" films. Since the word "fast" seems to connote "good" (i.e.: the "faster," the "better"), we often hear people bragging that they have a fast lens, although they may not really know what they are talking about. It is the lingo problem, again. In any event, as we shall see, we do not need to have a fast lens to shoot pictures from an airplane on a clear day. It helps to understand why the confusion arises so we turn to some considerations of some terms applying to lenses:

(a) Focal length,
(b) Lens speed;
(c) Field of view;
(d) Depth of field.

A BIT OF BACKGROUND

To understand the common terminology of photography which will be used, certain background information is needed. First of all, the term "35mm" as applied to the cameras we are talking about refers to the size, i.e.: the width of the film used in them, to wit: 1.36 inches. If you want to transpose from millimeters to inches, multiply by .039; if you want to transpose from inches to millimeters, multiply by 25.4. Since the 35mm craze started in Europe, we have used (read: accepted) the metric system in photography for more than 30 years. Remember, in metric mensuration 50mm may also be referred to as 5cm (five centimeters) and 35mm as 3.5cm. For quick estimates, 50mm is equal to two inches, more or less.

FOCAL LENGTH

The "focal length" of a lens is simply the distance, measured in millimeters, between the optical center of the lens and the plane of the film on which the image is to be focussed. This distance determines the size of the image to be reproduced on the exposed film: the shorter the focal length, the wider the angle of view to either side of the centerline, called the "axis of the lens," the smaller the images of individual objects will be on the exposed film. Conversely, the longer the focal length, the narrower the angle of view (sometimes called the field of view) and the larger the individual objects on the exposed film. The former, short focal length lenses, are referred to as "wide angle" lenses; the latter, long focal length lenses are called "telephoto lenses," or simply, "long lenses."

To make a comparison, the "normal" lens on most 35mm cameras is the best all-around compromise that the designers have worked out for the most common uses and "sees" just about what

the unaided human eye sees, without any perceptible enlargement or reduction of the image. For this purpose any lens having a focal length between 45mm and 55mm is considered normal. The 50mm focal length is going to be used hereafter for illustrative purposes because (a) it is one of the most common, and (b) it is what I have used most often. Besides, it is smack in the middle of the so-called normal range.

Taking the 50mm as normal, it can be seen that any lens having a focal length of less than 45mm is beginning to edge into the wide angle category and any with a focal length of more than 55mm is tending towards the telephoto class. For comparison, a 50mm lens has a field (or angle) of view of 46°, or 23° each side of the optical axis, and is considered "normal." My 28mm focal length (let's just call them "28mm lenses" the way everyone else does) replacement lens has a field of 74°, covering an angle 37° either side of the axis and my 200mm lens has a 12°20' field of view, while enlarging the object being photographed, like a telescope of medium power, 4x.

LENS SPEED

"Lens speed" is an optical term. It is computed by dividing the focal length of the lens (e.g.: 50mm) by the diameter (again measured in millimeters) of the maximum opening of the aperture of the lens. Note that it is not the actual diameter of the lens itself, but of the aperture, sometimes called the "iris" of the lens

Thus, if a lens having a focal length of 50mm also has a maximum aperture of 50mm across the iris opening, the division would be 50 + 50, or "1." The "ratio" would be expressed as 1:1, 1 focal length to 1 aperture. This ratio is imprinted on the lens body as "1:1" (sometimes as 1 = 1) and is called "an f/1 lens." It is referred to as a "fast" lens because it can gather more light, therefore can take pictures under lower light conditions than other lenses of smaller focal length-to-aperture ratios. The larger the ratio, the "slower" the lens is said to be. It gets to be a philosophical situation: how "fast" is "fast?"

Suppose I have a 50mm focal length lens which opens to 25mm maximum aperture. The ratio then is 25:50, or 1:2, ergo: an f/2 lens, in photography parlance. If the aperture is 6.25 mm (.24 inch across) on a 50mm lens, the ratio is 1:8 (50 + 6.25 = 8) or f/8. Cheap cameras have both fixed apertures and fixed shutter speeds, but good 35mm cameras have adjustable settings; not only that, they are designed to be precise.

USEFUL LENS SPEED

There is a difference between the optical lens speed which might be called theoretical useful speed and what is going to be required. If one is to take pictures only in daylight conditions, there is no real need to have an f/2 or even an f/4 lens; most pictures will be taken with the diaphram closed down, as the iris of your eye closes down when you go from a dark room into the bright sunlight. Therefore, the maximum f/stop rating (the f/stop ratio) of any good lens can be adjusted to meet the light conditions. To do this precisely, cameras have a series of f/numbers ("focal distance ratio") printed on the aperture adjustment ring so that the cameraman can select the most effective opening or "stop." The numbers from one extreme to the other may include the following (the ratio prefix "1:" is omitted because of space considerations on the scale): 1; 1.4; 2; 2.8; 4; 5.6; 8; 11; 16; 22; 22; 32; 45; 64. Note that if you take the 1 and 1.4 and double them alternately, you achieve the scale: $1.4 \times 2 = 2.8 \times 2 = 5.6$; the 11.2 is rounded off to 11. Increasing the number on each f/stop cuts the amount of light entering the camera by half; conversely, decreasing the number by each f/stop doubles the light passed by the prior setting; at f/5.6 the lens will pass half as much as f/4, but twice as much as f/8.

The extreme lens openings are seldom found on most cameras for the general market; about the normal range are f/3.5 and f/16, with a sprinkling of f/2 lenses for special uses. Which brings up another pertinent comment.

As the f/stop ratio gets nearer to 1:1 (f/1), it follows that more light is being focussed through the very edges of the lens itself, which raises all sorts of optical problems, hence the axiom that one should not use the widest opening of a lens if it can be avoided, since a lens is never at its best when used wide open. Let me explain why.

Over the years lens designers have learned to cope pretty well with technical problems such as spherical aberration, resolution, flares and ghosts—all lens problems which plagued early photographers—by applying coatings and mating pieces of glass together so that the ordinary photographer does not have to take all pictures with the sun behind him. However, these optical problems are harder to rectify as the lens grows wider so that it will gather more light, hence becomes "faster." The greater an angle at which light waves have to be bent to the point of focus, the greater the problems of astigmatism, aberration and loss of resolution.

If lens designers could work on the basis of a couple of aperture settings, say, f/8 and f/11, for 50mm lenses so that the light would pass through the center of the lens only, they could produce lenses

for much less cost to the consumer, for minor blemishes from grinding, or even a few tiny bubbles in the lens itself, would not matter all that much. Their dilemma is that they are producing lenses *capable* of f/2 operation and that costs money, although the lenses will be used at the tighter settings 99 percent of the time. To prove the point, look at some of the inexpensive cameras produced for the mass consumption market. Most of the cameras of this category have one (sometimes two) aperture settings—for bright vs. dull days—and some of the newer ones have "close-up" lense settings, as well. Howsoever, the lenses of those cameras are a far cry from the multi-element coated lenses of good 35mm cameras; in fact, most of the cameras built for the mass market have simple lenses: a single piece of glass, ground to prescription.

Having the versatility of a wide selection of f/Stops makes any camera more useful for a wide range of purposes, but for the special use of aerial photography, where pictures will be taken in broad daylight at settings somewhere between f/5.6 and f/11, depending on the ASA rating of the film being used, the conclusion is that a "fast" lens is not necessary and that buying a camera on that sole basis might lead to spending more money than you really have to, if you operate on a limited budget, as I do.

SHUTTER SPEED

Whereas lens speed is an optical term, shutter speed is a physical term; again confusion exists because of the use of the word "fast." The issue, again, is how to expose the film correctly.

Inexpensive cameras have "fixed speed" shutters, which is to say that the length of the exposure time can not be varied, but is set somewhere around 1/50th of a second, enough for snapshots. The tension built into a single inexpensive spring activates the shutter.

When we move up to better camera equipment, we find that they are equipped with mechanisms that allow us to change the shutter speed to meet the requirements of a wide range of subjects. On the side of the lens assembly, although normally a fixture on the camera body itself, is a scale numbered from "T" to as high as "1,500"; more often from some points in between, such as from "B" to "500." The "T" stands for "time exposure:" once you press the shutter release, the lens will open and stay open, until you press the shutter release again to close it. The "B" stands for "bulb;" the shutter will open when you press the shutter release and stay open until you release the pressure, whereupon it will close. The term comes from the old shutter activating system where the photographer actually squeezed a small rubber ball-like "bulb" which was

attached to the shutter mechanism by a length of rubber tubing, as studio portrait cameras are triggered, even now.

The other numbers stand for fractions of a second: "1" signifies 1/1 second, or 1 second; 2 signifies ½ second; 30 stands for 1/30th of a second, etc.; the top part of the fraction, the "1/" is simply ommitted in practice.

In order to capture quick action, such as a racing car going over the wall, a baseball player swinging his bat, a horse taking a jump, the shutter must be able to open and shut quickly enough to freeze the action, otherwise the image will be a blur. When one has a camera capable of shutter speeds of 1/1000th of a second or 1/1500th of a second, he can catch the stitches on a fastball or the water droplets from a wave crashing against a jetty. For good reason, these are known as "fast" shutters, although they are sometimes referred to as fast lenses, which is incorrect, or fast cameras, which is amateurish in the extreme.

What we said about the non-requirement for fast lenses for aerial shots also goes here. Most plane to ground shots are taken at either 1/25th or at 1/500th of a second so it is not *necessary* to have lenses as fast as 1/100th or faster, if you are going to stay with normal or short lenses.

THE BALANCING ACT

The reason for having adjustable apertures and shutter speeds has been alluded to before where we talked about fully manual control cameras and the use of the piece of paper in the film box in lieu of a light meter. Now, we can begin to understand the rule of thumb to the effect that every time you open the lens one stop, you set the shutter speed one click faster. The issue is called, as I said away back there, "exposure value" or EV.

Chemists who formulate film emulsions (the celluloid film is the "carrier" for the light sensitive emulsion which is applied to it, like a layer of paint on a roller-type window shade) have figured out precisely how much light—how much *exposure* to light—it will take to activate the chemicals in the film correctly and render correct color values. On black and white film, this is done by various shades of gray. Any more light than required results in an overexposure; any less, an underexposure.

Now comes the balancing act: Suppose we have been taking Kodachrome 64 pictures of friends on a sun drenched beach, with the exposure set at 1/125th of a second and f/16 and we see a bikini-clad girl being tossed in a blanket down by the water's edge. If we want to catch the girl in mid-trajectory, hair flying, we are going

to have to use a fast shutter speed, such as 1/1000th of a second. To maintain the exposure value we used at 1/125 and f/16, we are going to have to shoot the picture at 1/1000 and open the aperture to f/5.6. That change of settings will result in the same exposure value; if we just shot at 1/1000th and did not change the f/stop setting, we would wind up with an underexposed picture of an overexposed girl.

We have already noticed the doubling relationship of the f/stop series: each stop increasing in number makes the aperture smaller so that the amount of effective light passing through the lens is halved; each stop decreasing in number opens the aperture to allow twice the amount of light of the previous stop to enter. Now we can perceive that the same doubling ratio takes place in the shutter speed, if we do a bit of "rounding off" of the numbers; ½ second; ¼th; ⅛th; 1/15th (instead of 1/16th); 1/30th; 1/60th; 1/125th; 1/250th; 1/500th; 1/1000th. Each of these steps halves the amount of time of the previous setting (or, going the other way, doubles it). Thus, without reaching for a meter, you know that in the girl vs. blanket situation, the original setting of 1/25th takes three clicks to move the shutter speed to 1/1000th; to balance the exposure value, all you need to do is open the aperture by three clicks (they are called "detents") to f/5.6. Some cameras have the apertures and shutter speeds locked together to make it easier to maintain the correct exposure value while changing shutter speeds.

TROUBLE IS, IT COSTS

The faster a shutter mechanism opens and closes, yet with the capability of being varied over such a wide range of speeds *accurately*, the more exotic its engineering must be, because of the Swiss watch-like precision involved in both design and fabrication. It is also obvious that the speed range of the shutter does not stand alone but must be matched by a similar "speed" range of the lens also, for the aperture must work with the shutter speed to achieve the correct exposure. It follows that the lens to be used must be comparable with the shutter; since the shutter mechanism is part of the camera body and the aperature control (called the adjustable diaphragm) is part of the lens system, it does not make sense to put a cheap lens on an expensive camera body; they must be comparable to be compatible.

ABOUT DEPTH OF FIELD

Because you may become confused by the term "depth of field," which you will surely run across in reading or discussing photographic equipment, let's touch on it.

A discourse on optics is beyond the scope of this essay, but think of depth of field as a "zone of sharpness." It refers to photos taken at reasonably close distance. If the lens is opened wide, as to f/2, and focussed sharply on an object ten feet away, the far background will be fuzzy and indistinct—out of focus. A wide open lens has a narrow region or depth in its zone of sharpness, a result of the problems of bending light rays to the focal plane. As the aperture is reduced the zone of sharpness expands; at f/22 you can focus on an object as close as five or six feet from the camera and still have the mountains on the horizon in focus, too. The field of focus becomes shorter, or "shallower" as the aperture is opened up. An extreme example of narrow zone of sharpness, or depth of field, is seen regularly in studio portraits where the subject's nose is in focus, but his rear shoulder, only a few inches further away from the camera, is out of focus. Of course, for aerial shots, where focus is always set at infinity, there is no problem about depth of focus. I just thought I would mention it, in passing.

Chapter 5
About Long and
Wide Angle Lenses

As mentioned before, "normal" (any between 45mm and 55mm focal length) lenses see things just about as the unaided human eye does, with no magnification or reduction of the scene. As a rule of thumb, if you can see details on the ground while looking out the window—houses, automobiles, individual people—you can take the picture and will see those same details on a projection screen or an enlargement. There is no better lens for starting off than a 50mm-class lens, or normal lens.

However, every so often someone asks about using telephoto lenses, suggesting that since they magnify as a telescope or a pair of binoculars do, they should bring objects on the ground up close, instead of having to drop to a lower altitude to obtain the same effect. It is a somewhat valid question, but the answer has to be hedged, because *it* is not simple.

Many modern 35mm cameras have interchangeable lens systems so that the normal lens may be quickly replaced by a variety of special purpose lenses ranging from the very short 6mm focal length "fisheye" wide angle lenses to the "Big Bertha" 1200mm super-telephotos. Between these extremes lie almost two dozen focal lengths which may be considered. Things have changed in the last decade: when the so-called telephoto lenses first came on the scene, any photographer who showed up with one of those long black tubes sticking out of the front of his camera was sure to draw a crowd. For years the axiom was that the only purpose of a telephoto lens was to bring the subject closer and that a wide angle lens showed more in a

One of several "normal" lenses in the Canon system. This is a 55mm/3.5 lens detached from the camera body, for the purpose of comparing it with other Canon system lenses, following.

picture. Both statements are over-simplifications and both classifications of lenses are still misunderstood by just about everyone new to the hobby, a situation further muddied because sometimes the statement will be heard or read that there is really no need for wide

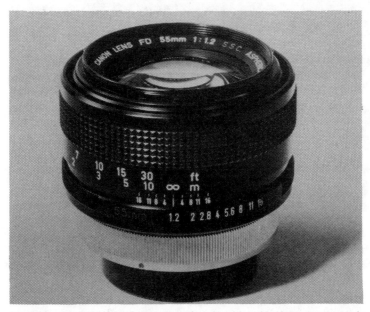

Another "normal" lens, the Canon 55mm/1.2. Note the wider face as compared with the 50mm/3.5 "slower" lens.

A super wide angle "fisheye" 15mm lens of the Canon family. This is a special use lens, not recommended for new photographers.

angle lenses, except for close-ups of groups, because "the wider the view, the vaguer the message." What they are saying is that, just the opposite of the enlargement of images created by the telephoto lenses, the wide angle lenses have the property of reducing the individual objects in the photo until they are undiscernable. People who make such statements bother me as they did Mark Twain, not because they don't know about lenses, but what they do know is wrong. Let's consider what these lenses will do and how they can be used for special effects.

STARTING POINT

First, let us consider how aerial photos-in-the-nature-of-snapshots are taken: they are either "grab shots" out of the windshield or side windows while the airplane is flying straight and level, as on a cross-country trip where you see someting, reach for the camera and shoot; or they are taken from a turning (circling) airplane at a specific target below. (This discussion will be primarily on air to ground shooting; air-to-air requires a subsequent chapter specifically covering that subject.)

Sitting in an airplane, one's view is not really downwards, but off to the side; when you are looking "down" it is most of the time at an

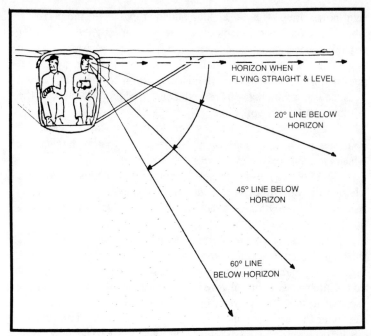

Normal scan area when flying straight and level, as on a cross country flight. Note that "straight down" is really about 60 degrees below the horizon line.

angle somewhere 40° and 55° down from the horizon; 45° is about average and 55° downwards can be seen only by pressing your forehead against the window when you look down (and generally leave a helluva grease mark on it). You can prove this to yourself

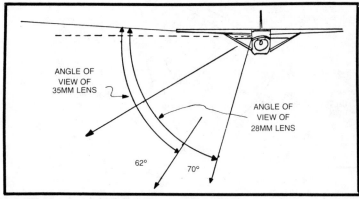

Using a 35mm focal length lens the horizon will show at the top of the picture as well as objects 62 degrees down. A 28mm focal length lens will include almost "straight down" as well as the horizon.

right now. Sit up straight, looking ahead at eye level (the horizon). Then turn your head to look off to the left; directly left is best for reasons you will understand in a moment. Now look downwards at an angle normally used when looking off to the side, and point that direction with your left hand. (I am using the off-to-the-left direction because I am assuming you are a pilot and all pilots can look off to the left in normal flight conditions.)

The angle of your arm measured down from your shoulder will be in the 40° to 45° range, most of the time. That is the angle at which *most* en route aerial shots are made.

For shooting specific targets, whether it be a house, a Spanish Mission or Meteor Crater, one usually engages in circling flight, wing down, so we turn to a practical consideration of how *much* wing down.

Most "normal" turns are made with the airplane banked at 15°, the angle sometimes referred to as the standard rate of turn which produces a 360° turn in two minutes. Any steeper bank than that edges into the category of aerobatics, for it has the effect of raising the stalling speed of the wing. In other words, the steeper the bank, the faster the airplane must be flying, or else it can get into controllability problems. A really steep bank, what *seems* to be a "vertical" bank (i.e.: a 90° bank) is really no more than a 60° bank, in most

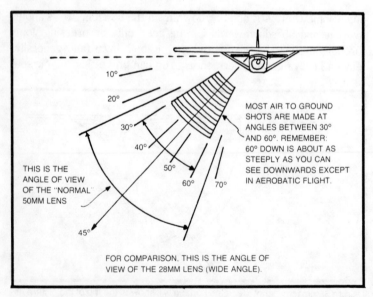

Most air to ground shots are made at angles between 30 and 60 degrees down from the horizon. If taken at 45 degrees, this is the angle of the field of view.

cases. You don't need instruments to tell when the bank is getting too steep; your wife will start screaming at you and your passengers will swear off flying with you again, ever. A 45° bank is about all you can manage without losing friends and inducing uxorial tension.

OPTICAL AXIS AND SIDE VISION

The center of the picture, usually the object which is being photographed, is on the optical axis of the lens. However, the lens will also see off to the sides as well; this field of view is actually in the shape of a cone expanding outwards from the lens, but for illustrative purposes, can only be drawn as lines in two dimensions. It must also be realized that not everything in the cone of vision will be registered on the rectangular negative; by its very dimensions more will be seen on the negative's long dimension than on its short one, with the longest dimension being measured on the diagonal, as with a television screen.

A 50mm lens will see approximately 23° either side of the optical axis, hence is said to have a 46° angle of view, sometimes called its "field" of view. Shooting straight down from an altitude of 1,000 feet, a 50mm lens will capture the image of an area approximately 450 feet by 700 feet, or 315,000 square feet, without enlargement or reduction, as we have said.

TELEPHOTO LENSES

Telephoto lenses, properly called long focal length lenses, or simply long lenses, because they have longer focal lengths than the normal (50mm-class) lenses, have the ability to bring the object being photographed apparently closer, as a telescope or pair of binoculars will do for the naked eye. Picking out a couple of my own most used long lenses, the 85mm and 200mm, we can make an interesting comparison with the normal 50mm lens.

The 85mm lens has a field of view of about 30°, (in the specifications it is 28°30', but throughout this text I am rounding off all specifics for reasons of clarity; in any case, the 1½° difference is trivial) hence will see only 15° either side of the axis. However it just about doubles the linear dimensions of the object being photographed and exposed on the negative. At the same time it reduces the area: from 1,000 feet a vertical shot will cover an area approximately 300 feet by 450 feet, or 135,000 square feet. When the magnification is doubled, the area covered is reduced by half.

What this means in aerial shots is that using the 80mm lens you can fly at 1,000 feet and still obtain the same size photo of, say, a

The best long lens to start with: the 85mm Telephoto. It is not much larger than the "normal" lens, yet will produce excellent results without suffering from vibrations from the airplane. My first recommendation for an auxiliary lens.

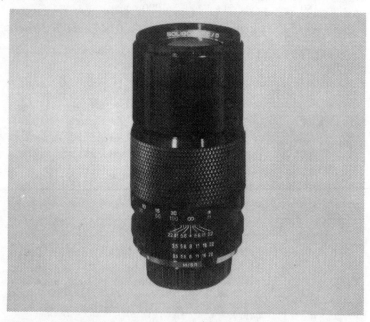

Soligar's amazingly compact 200mm lens, just about the greatest magnification that can be hand-held. It is about the extreme for aerial photography and you still have to be lucky to eliminate vibrations aloft.

CLOSE-UP
EFFECTS OF
VARIOUS LENSES
FROM 500 FEET
(FIELD OF VIEW)

50MM LENS
80MM LENS
135MM LENS
200MM LENS

50MM
80MM
135MM
200MM

HOW LONG A LENS DO YOU NEED?

A representation of a photograph of a house taken from an altitude of 500 feet with 50mm, 80mm, 135mm and 200mm lenses. Showing comparative fields of view.

house that you would only be able to obtain with the 50mm lens by flying at 500 feet, or so.

The 200mm lens will produce even greater magnification, expanding the object's linear dimension some four times that of the 50mm normal lens apparently bringing it in closer. However, the angle of view is reduced to a mite over 12°, so that everything more than a mere *six* degrees off the centerline, or axis, will be beyond the limits of the photograph. From our standard altitude of 1,000 feet, about the best for the 50mm lens, a vertical shot by the 200mm would show an area slightly less than 125 feet by 175 feet, or 21,875 square feet. Now you can see that it would be possible to fly at 2,000 feet and still be able to make a picture that could only be made from 500 feet with a normal lens.

WHOA!

Trouble is, there are penalties to this degree of magnification which must be considered. For practical usage as the focal length of a lens, and its magnification power, is increased, movements of the camera are also magnified on the film. Small vibrations, easily accommodated by the 50mm lens at 1/500th of a second, are so emphasized in the longer lenses that they frequently result in a blurred negative, an out-of-sharp focus, so that when the negative is enlarged or projected on a viewing screen, in the case of transparencies, it is seen as a poor quality picture. Oh, boy! Is that embarrassing and distressing. I know.

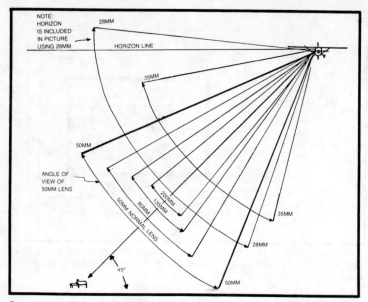

NOTE: HORIZON IS INCLUDED IN PICTURE USING 28MM

HORIZON LINE

28MM

35MM

50MM

ANGLE OF VIEW OF 50MM LENS

50MM NORMAL LENS

80MM

135MM

200MM

35MM

28MM

50MM

45°

Comparative fields of view with six classes of lenses normally used with 35mm cameras.

A couple of years ago I was involved with a sailing regatta on the Chesapeake Bay's Eastern Shore, as a guest, I must add. Marianne and I had flown in to Easton Airport where we were picked up and driven to the marina for an evening of pre-race festivities and lie-swapping. The next morning, while the sailboats were being set up for the race, we went back to the airport, loaded the Nikkormat with a roll of Kodachrome 64 and plugged in the 200mm lens. Then we circled our host's sailboat for an hour or so at 1,000 feet or so, taking picture after picture of it on the sparkling water. I had planned to take the best of that roll for an enlargement in full color and give it to him for Christmas. When the transparencies came back from the lab, we quickly set up the projection screen to make our choice for the proposed gift. None of them were acceptable. I had been shooting at 1/500 of a second shutter speed, but it was not fast enough, every picture was just a little bit off precise focus. Of course, the answer came to me a few days later; when I enlarged the magnification four times, it was roughly equivalent to reducing the shutter speed that worked so well with the lower-magnification lenses by four, as well. My 1/500th on the 200mm was about the same as shooting the 50mm lens at 1/60th.

My experience is that the 200mm lens is a bit too large to use for aerial shots by myself; it requires a very smooth day, a two-hand

hold and someone else flying the airplane. Those prerequisities add up to one thing: using the 200mm lens is a production. It is not for grab shots or for casual photos, but requires advance planning, and a smidgin of luck.

INTERMEDIATE TELEPHOTO LENSES

From my personal experience, the 80mm to 85mm long lenses are the most valuable to the aerial photographer for either air to ground or air to air, as we shall discuss later on. However, the 100mm/105mm and 130mm/150mm range groupings also offer interesting possibilities, with the caution that the greater the magnification, the less all-around usefulness the lens will probably have, and my own philosophy is, if I ain't gonna use it, I can spend the money more wisely elsewhere.

WIDE ANGLE LENSES

Since some apparently uncomplimentary remarks have been made hereinbefore about wide angle lenses, what I am about to say may seem contradictory, but it is not. What I said was that the wide angle lenses on inexpensive small cameras for the mass production market, including the 110 group and the self-developing types should

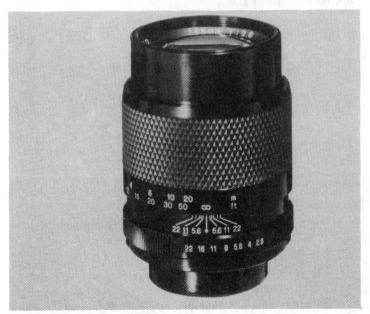

The 135mm intermediate telephoto lens is one of the very best for aerial photography, with its 18-degree field of view. This one is made by Soligor.

not be relied on for *all aerial* shots. I also recommended that a small 35mm camera with either a 38mm or 40mm lens should be carried to record certain details of your vacation trips. I chose these cameras for two reasons: first, they produce exactly the same size transparencies and negatives as the larger SLR 35mm cameras, so that you won't have to fool around with different size end-products, and second, having a camera of the semi-wide angle lens variety eliminates the need for buying a separate, interchangeable semi-wide angle lens, with the requirement of switching lenses in flight. For several years I have carried a Rollei 35S for just these reasons. However, let us examine some wider-angle wide angle lenses.

We have seen that in long lenses, as the magnification increases, the angle of field narrows and the field of view is reduced. Just the opposite is true at the other end of the lens types: the shorter the focal length, the wider the angle of view and the smaller every individual image on the picture. The wider the angle, the greater the distortion, to the point where details you might want to capture are totally lost. This is not to say, however, that a wide angle does not belong in an aerial photographer's camera bag; in fact it is one of the most useful lenses in the battery of lenses for the purpose.

BACK TO THE BENCH MARK

Let's go back to the 50mm normal lens for the purpose of comparison. The 50mm lens has a 46° field of view. As we said

A 24mm wide angle lens is about the extreme size for most aerial shots, with a field of view of more than 75 degrees.

The 28mm wide angle lens is used by professional photographers from the air to obtain an overhead view of an object on the ground and still include the horizon.

above, if we take a picture of an object on the ground, 45° down from the horizon, our normal scanning angle if we eyeball the ground while flying, the top part of the photo will be some 22° below the horizon line and the lower part, and the bottom edge of the photo will be 68° down from the horizon, about what you would see if you press your head against the window and look down.

The 35mm lens is the compromise wide angle with its 62 degree angle of view.

My 28mm focal length wide angle lens has a field of view of 74°, so it will pick up everything 37° to the sides of the optical axis, therefore if I aim at a point 30° below the horizon line, the horizon will show at the top of the picture and the bottom of the picture will be some 67° down from the horizon. The bottom parts of both the 50mm and 28mm pictures will be about the same angle down from the horizontal, but only the 28mm shot will also show the horizon. Unfortunately, the distortion is excessive for most purposes, so the 28mm lens has too much wide angle for routine or ordinary aerial use.

OPTIMUM WIDE ANGLES FOR AIR SHOTS

The best compromise lenses for wide angle photos seem to be in the 35mm to 40mm range, and I believe that either choice will be excellent. My little pocket model Rollei has been almost perfect for the purpose, but I have been eyeing a 35mm focal length wide angle, anyhow. With a 62° angle of view, the 35mm produces less distortion, while enabling photographs that can include the horizon and still include what I see down to 60° from horizontal. If you belong to the National Geographic Society and receive the *National Geographic*, take a good look some time at the magnificent aerial shots included in almost every issue of that journal. Virtually all of the *Geographic's* photographs are made with 35mm cameras and many of those sweeping all-inclusive aerial shots that show endless vistas stretching out from a city or town almost below the airplane are made with 35mm focal length wide angle lenses.

PRACTICAL USES FOR WIDE ANGLE LENSES

Since some detail is lost when you use shortie lenses, they are best used at low altitudes, 1,000 feet or less, and out of the side windows of the plane, especially a single engine plane where the engine sticks out front and blocks the wide angle downward view of the lens. For over-the-nose shots, stick with the normal or shorter versions of the telephoto lens types.

Wide angle lenses also make another type of picture eminently practical: inside shots of the airplane while in flight. We have some great pictures of ourselves and our friends en route to various health resorts. A few of those pictures were taken merely by holding the camera at arm's length and taking the picture back from the glare panel. One picture I particularly treasure is one of my wife and a friend sitting in the rearmost seats of our Cherokee Six enjoying martinis while we guys sat up front dry as a bone, in accordance with

A zoom lens adjustable from 28mm (wide angle) to 50mm (normal) settings by twisting the knurled ring at the lower part of the lens barrel. An interesting lens for the advanced cameraman. A Canon lens.

the no-drinking-while-flying philosophy. Come to think of it, once we were back on the ground, we caught up pretty fast.

We also take photos of the entire instrument panel taken in flight, courtesy of the wide angle lens. I have a picture of the panel of my old Apache (now deceased) as it labored over the Sierra Madre Mountains of Mexico at 13,000 feet, showing the altimeter all wound up, the manifold pressures at full throttle registering a scant 13 inches and one oil temperature in the red arc. I also took a picture of Marianne on that flight; she was wearing an oxygen mask because of the altitude and was mad at me because I had just called her "Dumbo" and offered her a peanut.

ZOOM LENSES

Up to this point, you may have noticed that I have been enthusiastic about one lens only, the normal 50mm category that comes with most cameras as standard equipment, and that my discussions of both long and wide angle lenses has been somewhat restrained. There is only one reason for this: I have been waiting for you to read this far. I am not changing my mind about the 50mm lens, but if you are going to spend any money for some additional equipment I unhesitatingly recommend that it be one of those remarkable new developments called "zoom" lenses.

Canon makes this zoomer from the compromise wide angle to the compromise long lens: 35mm to 70mm. Another interesting lens for aerial work.

Within the last few years optics engineers and lens designers have overcome some incredibly complex optical problems and designed a new family of lenses which cover a wide range of focal lengths in a single assembly. Simply by twisting a knurled ring the cameraman has instant ability to change the focal length—and the imagery—from wide angle to telephoto, or from telephoto to super-telephoto, without changing lenses on the camera. They are called "zoom" lenses because in a SLR camera, where you focus through the objective lens, you can *see* the object being photographed grow

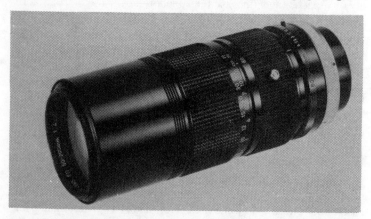

Canon's zoom lens that covers all focal lengths between 80mm and 200mm—just about what the doctor ordered for most air to air shots. Holding the airplanes 150 feet apart for safety, a photographer can bring it in close optically and compose the photograph. The 200mm focal length may not be used much, but it is always available.

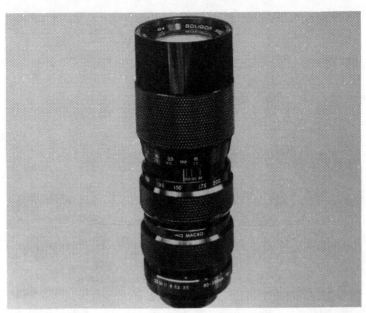

Soligor's 80-200mm zoom lens includes the extra close-up "macro lens" feature: you can photograph objects, such as an instrument on the panel or a chart, from as close as eight inches!

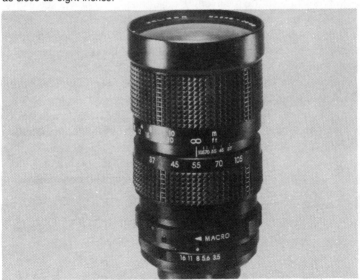

Possibly the best all-around zoom lens for aerial photography is the 37-105mm version, which gives both wide angle capability and intermediate telephoto in one lens. This one is made by Soligor and includes the "Macro" lens function: for extremely close-up photography, as well. It is available for most top-grade camera bodies, including Pentax, Minolta, Konika, Olympus and Nikon.

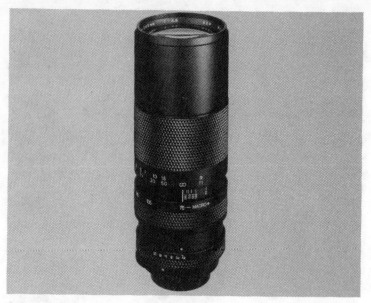

Soligar also makes zoom lenses like this 75-260mm and 85-210mm, 85-205mm, 90-230mm zoom-Macro lenses, to fit various makes of camera bodies.

larger as you turn the focal length adjustment; the image seems to explode in size, or, to put it another way, you seem to zoom in on it. You can focus the lens set at any focal length. Once focussed, it remains in focus throughout the entire range of focal lengths of the lens, from wide angle to telescopic, without resetting.

Three of these lenses are most interesting for aerial use: the 37mm–105 mm zoomer, the 80-200mm and the 50-300mm zoom. My first choice is the 37-105 version; at the 37mm focal length it has a field of view of more than 63°, wide enough to include the horizon and still catch objects on the ground as far as one can see from inside the plane when flying straight and level. At the 105mm setting, it has a 27° field of view and just short of a 2X magnification. The 80-200mm zoom is a little on the high side, although it ranges through the 135mm focal length, which is excellent in the telephoto range, and would be my second choice. The 50-300mm zoom lens is scarce and horribly expensive. In any event the 37-105 version offers more all-around versatility for the flying photographer and I really believe that this one zoom lens will do for 99 percent of all our photographic requirements, and yours, too. Don't rush right out and lay down a bundle of frog skins for it right away; learn to use the basic camera, first. But when the time comes for that next lens, keep this zoom lens in mind.

Chapter 6

New Cameras

No one ever has any problem finding a new camera of the 35mm type, for there are more than two dozen that are so widely distributed that every town of any size has at least one camera shop vending them. The competitive pressures are so great that virtually all single lens reflex cameras available will be more than adequate for all but the highly specialized professional photographer. You really cannot go wrong with any modern 35mm SLR that has a normal lens between 45mm and 55mm, coated lenses, interchangeable lens capability and a built-in light meter. The first step, usually, is to buy the basic camera. After using it becomes almost second nature, and you have had an opportunity to review the results of your early efforts, you will have a better idea of which way to move, with respect to future equipment acquisitions, either lenses or such exotica as motor drives.

HOW MUCH?

Prices—*list* prices—of 35mm cameras vary from $1,000 for the ALPA to $189.50 for a Sears Roebuck 500MX outfit. Don't knock the Sears camera, it is of excellent quality with a 50mm f/2 coated lens, a built in light meter, shutter speeds from 1/30th to 1/500th *AND* a 135mm telescopic f/2.8 lens, as well. Also included in the price is a flash attachment and a gadget bag.

List prices are about as reliable for planning purposes as airline schedules. A few of the most-wanted, or most-desirable SLRs, which is to say, the most expensive ones, hold up, but the great

Always a favorite with professional photographers: the Canon AE-1, with a 50mm/1.8 lens.

middle-ground can be bought at discounts all over the place; discounts of 20 percent to 30 percent are frequently found, so any "recommended price" list is to be read with that thought in mind.

ANOTHER CAVEAT

It is always recommended that you deal with a retail establishment in your home town, or one that you will be visiting regularly, so that you will get to know the people with whom you are dealing. Be wary of special cut-rate deals advertised in the newspapers, especially those which include only a post-office box number, not a street address. If you cannot reach a company by telephone, a red flag should go up. After all, even for the cut-rate prices, we are not talking about peanuts.

Because it always helps to have a definite starting point in mind, so you don't traipse into a camera emporium with a look of wonder on your face, it might pay right here to list some of the better known makes of 35mm SLR cameras. At least you can stride briskly up to the counter and ask for the latest brochure on a specific camera line.

If the salesman says he doesn't carry that line and suggests another that he does carry, you can smile brightly and say, "O.K. How about *that* one?" If you don't say too much, you convey the impression that you are one of the gang.

Cameras Available on U.S. Retail Market

Alpha	Nikon
Canon	Olympus
Contax	Pentax
Exacta	Practica
Fujica	Rollei
GAF	Ricoh
Konika	Sears, Roebuck
Leica	Topcon
Mamiya	Vivitar
Minolta	Voightlander
Miranda	Yashica
Nikkormat	

HOMEWORK

Before you go to a camera store, you can become well educated by reading a couple of publications obtainable either at the corner newsstand, the local drugstore, or directly from the publishers. At first, do not buy up a bunch of the monthly periodicals on photography, because you will be overwhelmed with information that may be very confusing. I recommend two publications in particular: *Photography Directory & Buying Guide*, published by *Popular Photography*, a division of Ziff-Davis Publishing Corp., One Park Avenue, New York, N. Y., 10016, and *Photo Equipment*, a publication of Buyer's Guide Reports, 1410 East Capitol Drive, Milwaukee, Wisconsin, 53211. Both of these publications set out a full array of photographic equipment, from cameras to enlargers, projection screens, etc., and Photo Equipment makes recommendations for best buys for new acolytes at the shrine of photography and are plantinum mines of information. Unfortunately, some of the prices quoted for cameras will stand you on your ear unless you have enough background to winnow out the facts that you and I can get by and do a great job with the least expensive of the 35mm cameras with *normal* lenses. I keep stressing that word, so that your thinking will be attuned to the key expressions, "50mm" and "55mm" when you read the advertisements or other literature. For regular use aloft, the 38mm and 40mm focal length lenses will not do.

The Canon TX is one of the best "beginning" cameras available, for several reasons. First: it may be purchased for $200 in most busy camera stores. Although its list price is more like $300, it is still a good buy at that price too. Second: it has both a "fast" lens and a "fast" shutter on its normal 50mm lens. Third: it can use every wide angle and telephoto lens in the Canon array. It is a magnificent introduction to the Canon "system" of photography, without paralyzing your bank account.

There are a number of cameras available for less than $300. Although that magic figure has been used as the "ball park" price for the lower list-price SLRs, the figure has been reduced even more in the last year or two, so that a number of excellent cameras are available for prices in the $200-$300 range—and, remember, most of these cameras can use interchangeable lenses!

SOME CHEAPIES BUT GOODIES

In many cases, the cameras listed here carry much higher "list" prices than they are actually sold for, across the counter, a situation sometimes called discounting, a euphemism for price-cutting. Whether the marketing premise is "double the retail price and give 'em a 30 percent discount," I am not qualified to say, but only a

A complete layout of the "Canon system" showing all the lenses from super wide angle to 1200mm focal length telephoto, motor drive (lower center), 250 exposure attachments (upper center) filters, remote control systems and carrying cases. All of these can be used on the low cost Canon TX as part of a building-block development of equipment.

novice will pay the price he sees on the camera without at least haggling, or shopping around some more. After all, we are talking about a respectable amount of money.

In any event, here are some good, low-cost cameras for starters which will not break you financially:

Make	Model	Standard Lens	Mfr's Lenses Available	List Price	Over the Counter Price
Canon	TX	50mm; f/1.8	all	$300	$200, or less
Canon	AE-1	50mm; f/1.8	all	$420	$300, or less
Fumica	ST605	55mm; f/2	all	$240	$150, or less
Konika	Auto TC	50mm; f/1.7	all	$300	$200, or less
Konika	Auto NT-3	57mm; f/1.7	all	$520	$250, or less
Nikon	FM	50mm; f/2	all	$487	$300 & up
Nikkormat	FT3	50mm; f/2	all	$297	$200 & up
Olympus	OM2	50mm; f/1.8	all	$600	$300 & up
Sears Roebuck	500MX	50mm; f/2 and 135mm; f/2.8		$189.50	(same)
Vivitar	SLR35	50mm; f/1.8	all	$220	$150±

ADDITIONAL LENSES

The cost of auxiliary or interchangeable lenses is also widely varied, depending on the manufacturer and the focal length of the specific lens. Using the 50mm or 55mm focal lengths as our standard or bench mark, we can list their prices in a range between $95 and $175, depending on who makes them.

Wide-angle lenses cost between $60 and $455 (list) generally as follows:

focal length	price range
10mm	$780
16mm	$160-$455
20mm	$ 90-$280
24mm	$ 80-$207
28mm	$ 76-$350
35mm	$ 47-$160

For Telescopic lenses:

85mm	$150-$170
100mm	$ 50-$150
135mm	$ 50-$150
200mm	$ 50-$150
300mm	$ 82-$275
400mm	$145-$625

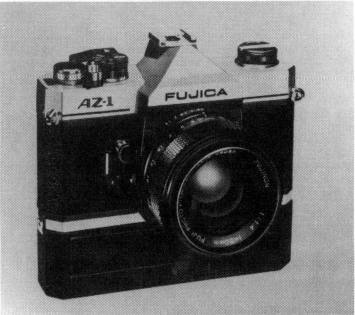

The Fujica AZ-1, shown without (top photo) and with (bottom photo) its motor-drive pack attached, now comes with either a 50mm "standard" lens or a 43-75mm zoom lens as standard equipment, at the buyer's option. Range of image control covers most of the useful focal lengths from slightly wide angle to medium telephoto, and is reasonably priced.

This weird looking gadget is a "spot sensor." Sort of a second cousin to a police radar gun, it can be used from aloft to ascertain what the light values and exposure values are on the ground through a hole in the clouds, without being affected by the surrounding glare reflected from the cloud tops. For professionals, mostly.

And for the Zoom Lenses:

	Price Range
28mm-45mm	$150-$375
37mm-105mm	$189-$236
43mm-86mm	$140-$212
50mm-300mm	$875
85mm-300mm	$517
75mm-205mm	$170
85mm-250mm	$175

Remember, these are approximate list prices and it must be assumed that, before you begin to build an extensive battery of interchangeable lenses, you will shop around and pick up all the brochures so that you will be armed with enough specifics to make an informed judgment.

COST AS AN INDEX

As a general rule, the more expensive a piece of machinery is, the higher its quality; hence many people, who have the wherewithal

to plunk down a sizeable wad of money, can pick the most expensive commodities without batting an eye and will do so, as a matter of normal routine. They are the kinds of people who buy Mercedes instead of Mercury, mink coats, instead of mink-dyed muskrat and Purdey Shotguns, instead of Stevens—although the more expensive items will not do any more for the novice than their less expensive competitors. It is simply a matter of choice; you get the best you can afford, and go with it.

And, to tell you the truth, *most* people can have just as much fun and produce just as good results with the lower-cost versions.

Chapter 7
How To Buy A Used Camera

Unless you are afflicted with the psychological feeling that buying anything "used" is somehow socially degrading or are hung up about always acquiring the "top of the line," as some sort of a badge of affluence, it is possible to obtain quality equipment with a reasonably low investment of capital.

From what has been said before, you know what you need to get started. More importantly, you know what you do *not* need, so you won't be conned into buying more than will be required. There is a parallel situation: golf. A beginner does not have the skills to obtain the full benefits obtainable of a set of graphite gold clubs designed for the professionals and advanced amateurs, nor does an acolyte in the art of fly fishing have to spend several tons of dollars on the most expensive split bamboo rods at the local fishing goods store. What you want is a 35mm camera, with a normal lens (be sure that it is marked on the lens itself with either "45mm," "50mm" or "55mm," not "35mm," or "40mm"). You do not *need* a light meter; you do not *need* a "fast" lens; you do not *need* a "fast" shutter. Nor do you *need* either a telephoto or wide angle lens, to start. Knowing what your basic requirements are, you can quickly zero in on a suitable aerial camera without a lot of hemming and hawing.

SOURCES OF USED CAMERAS

Three sources of used cameras exist: (a) individuals who for one reason or another want to sell their equipment; (b) hock shops, where cameras in inventory are unredeemed pledges for loans, and (c) camera shops.

Buying a camera from an individual, unless you know him, and possibly the camera's history, can be risky; on the other hand, it can also be a good deal. Remember the legal doctrine of *caveat emptor*: let the buyer beware. It is your decision, so try not to make a bad one.

It pays to be especially careful if you do not know the individual who is offering the camera for sale, especially if it is a late model camera offered for a ridiculously low price. It is reasonable to caution you to explore the possibility that the camera may be, as the saying goes, "hot," for there is a brisk business in stolen cameras, especially around big cities. Since all good cameras and their accessories carry serial numbers (and when you buy one, be sure to record the serial numbers for insurance purposes) a stolen camera may be reported by the victim as part of a police investigation. The police, in turn may forward the information to the camera company's U.S. headquarters and they, in turn, may send the information to their reputable dealers and repair shops. Then, one day, when your recently acquired camera is off being repaired, you may find yourself engaged in an embarrassing conversation with some badge-bearing callers, inquiring about where you got it. To top matters off, you may never get it back, since it will be returned to its rightful owner.

This may seem like a remote possibility, but it nevertheless exists and any lawyer will advise you that it is only good business practice—and for your own protection—that you insist on, and receive, a bill of sale when you buy anything from a private individual. Furthermore, continuing a bit of legal advice, remember that there are no warranties of fitness when you buy from an individual; if the purchase is junk, you are stuck with the loss.

It may sound peculiar, but do not buy a used camera from a professional photographer unless you know him very well personally, no matter what make of camera he may expose for sale. Cameras are to professional photographers as knives to butchers, scissors to barbers and taxicabs to New York jitney drivers: they are tools with which to make money. As long as the tools work, as long as the blades retain an edge and the cab, or camera, will do the job, it will be used. The workman's tools are disposed of, as a general rule, only when they are no longer useful. The closest aviation simile is buying an old training plane with a run-out engine, especially one that has been used for primary instruction. The odds are that a used camera obtained from a real busy pro is going to be comparable to either the run-out training plane or to a New York taxi cab. No matter who made it, it is most likely to be mechanically moribund, just plumb wore out.

ON THE OTHER HAND...

Not all purchases from individuals are bad news. A few years ago, one of my wealthier acquaintances, having seen some pictures that Marianne and I took on a jaunt in our Sturdy Bird to Mexico, was impelled to out-do us in every way. He called a travel agency and booked himself and his frau on what was billed as a "photographic safari" to Kenya, Africa. "Spare no expense," he said, in a grand gesture of more-money-than-brains. If it had been a real safari, the kind where people shoot guns, he would have plowed into Abercrombie & Fitch and saved them from bankruptcy. Instead, he went to a large photographic shop, checkbook unfurled and loudly demanded a complete outfit of camera equipment of the highest quality, top of the line, with all accessories. And, brother, did they sell him some equipment: all Nikon, the whole nine yards. He soon owned a complete assortment of lenses, extra camera bodies, tripods, every lens filter in stock, carrying cases, photoflash equipment, and bellows attachments. Part of his problem was that he somewhat insultingly said that he wanted "automatic-everything" cameras that would enable him to point the camera and take pictures, then ordered the salesman to "snap it up," his chauffeur was waiting, which led the store people to include a motor drive attachment with the 250 exposure magazine back. The outfit *had* to cost $5,000.

Neither he nor his wife ever bothered to take any instruction in the use of that magnificent inventory, not even how to load the cameras. As a result they came back from what must have been a sensational trip without a single picture, whereupon the equipment was piled up in a glass-front bookcase in their game room and left to collect dust. Three years later, he needed the shelf space for some other use, and sold everything in the camera line for a fraction of its cost. For some lucky stiff, it was like buying a three-year-old Mercedes from a little old lady who never used it except to drive to church on alternate Easters. I just wish I had been there when all that equipment went so cheaply.

To a large degree, warnings applying to buying cameras from individuals apply equally to pawn shop purchases: they may be hot, they may be junk (remember, no warranties!), or they may be legitimate and in good shape. It is like buying a pig in a poke. You just don't know when you pay the money. I must say that there is no way for a novice to be sure that a used camera is in working order just by looking at it. Remember, if you deal with a thief, the odds are that you will be robbed.

A RECOMMENDATION

Accordingly, it is recommended that you deal only with a full service camera establishment, preferably one in your home community that has been in business for some time and plans to stay in business at the same old stand. Keep away from quick-buck and/or cut-rate operations which offer "deals;" you can usually do just as well, or better, with your local retail dealer. Besides, human nature what it is, the odds are that if the dealer treats you right, you will keep returning to him in the future. In business, this is known as "good will."

ABOUT USED CAMERAS

Don't shy off because you think a camera shop will not want to deal with you if you ask to look at some used cameras. Any reputable dealer will be more than happy to show them to you, for a basic economic reason: it is profitable to sell used cameras. More than that: they make more money on used cameras than they do on new cameras.

Busy camera dealers take many used cameras in trade to encourage sales of new cameras. It must be understood that the "mark-up"—the ratio between the dealer's acquisition cost (wholesale) and the sales price (retail)—is usually greater on used equipment than it is on new equipment. Since the profit margin is wider, he makes more of a percentage of return on investment—economists call it "ROI"—on old equipment than they do on new. The numbers may not be as large, but the ROI is better.

Having specific requirements in mind, ask to look at cameras carrying the names of well known companies still in existence—be sure to get that straight, because some very good companies (e.g.: Allied Impex, which manufactured the fine Miranda cameras) have gone out of business. The continuance of a manufacturing business gives at least some assurance that repair and replacement parts will be available, as well as accessories.

Do not buy by name *only*, because some trade-in cameras may be pretty well worn out; look several of them over and take your time doing it.

SOME PRELIMINARY CHECKS

When the salesman hands you a camera, take it in both hands and gently shake it, then hold the body in one hand and gently rock the lens assembly around with the other hand. To funition properly, the lens assembly must be tight enough not to rattle or move around,

5⅜"

3¼"

The innards of a camera show clearly why it won't stand much dropping. This is an Olympus OM-1 SLR which is smaller over-all than most 35mm cameras, but can also accommodate the entire line of Olympus wide angle and telephoto lenses. Not the way the six elements of the lenses are related and the position of the angled mirror which springs out when the picture is taken.

yet all setting controls for shutter speed and aperture selection must be smooth and not grating or grinding. If it rattles as you jiggle it, put it down and move to the next.

If the lens assembly is tight, ask the salesman if the shutter speed has been checked for accuracy; if it has not, ask whether you can take a few pictures with the camera if you buy the film for a test series. Sometimes a reputable camera store will allow this. If not, ask the salesman if there are any warranties on the camera and be sure to get them in writing if you do lay out a reasonable amount of money. Again, *reputable* camera shops will do this, too.

Examine the camera body for nicks, bumps and deep scratches, especially for battering at the corners of the body, indicating that the camera has been dropped. Check the loading hatch and be sure that it closes tightly, though easily; it must fit perfectly and be absolutely light-tight.

Minor scuffing, what might be defined as normal wear and tear, should not deter you from buying a camera, but signs of hard use and

　　　　　　　　　　text continues on page 73

Dramatic view of a fortress-like structure seeming to rise out of the surrounding countryside.

An impressive mountain shot where snow-capped peaks become lost in the clouds.

A barren scene broken up by the hint of life in the background.

A snow-capped scene taken with part of the wing in the foreground.

abuse are a warning to be extra careful. Don't forget to examine the lens for scratches or damage to the coating on the lens, if it has a coated lens, and most of them do nowadays. Look closely at all screws, lens fittings, latches and hinges. Burred screw slots are an indication that someone has been doing some amateur repair work on the camera's delicate mechanism. Taking along a magnifying glass (one of my photography-bug sons carries a jewler's loupe!) helps to see details not obvious to the naked eye. The point is that you don't want to buy a piece of junk, which is not a bargain at any price no matter what company's name it carries.

Since you don't need a "fast" lens, any apertures between f/5.6 and f/11 (or f/16) will be adequate for your fair weather photography and shutterspeeds between 1/60th and 1/500th (or even 1/250th) will be adequate, at first.

Although you do not need either a wide angle or telephoto lens at the beginning, you may want to decide whether or not the used camera you are looking at should have the faculty to use inter-changeable lenses, and if so, ask what are available for that make and model.

TAKE A DEMO

Once you have selected the camera you want, have the sales-man show you how it works, how to adjust the aperture and shutter speeds. Be sure that before you leave the store, you know how to load it and unload it! In view of the fact that every camera has a slightly different design, it is not surprising that many people walk out of camera shops with new cameras in hand and don't have the slightest idea of how to do these fundamental things with their equipment. I'll take it a step further: buy a roll of out-of-date film (camera shops always have some around) and *practice* the loading and unloading operations right there at the counter, until the physical actions become habitual, almost automatic. Then, when you pick up the camera, your fingers will fall into place on the shutter and aperture adjustments, as well as the cocking lever and the shutter release. Out of date film may be bought cheaply and if you buy a camera, new or used, a store owner should throw in a roll or two of outdated film, for free.

You should know how to set and use the exposure counter, so you can always tell how many shots are left (some counters count upwards, from 1 to 20—or 36—and some count backwards, down from the full count to 1).

Don't be confused by terms like "focal plane shutter" and "between the lense shutter" and "iris-type shutter;" all you care

about is *results*, which means how to set the shutter speed and assurance that it works and will produce the correct exposure.

If the camera has a built-in light meter, you should be able to use it, even though you don't need it (remember the directions in the film box) and be sure to learn where the battery is and how to change it.

Not long ago a friend who has a little pocket Rollei 35S like mine, told me at lunch that his was broken and he was going to send it to the factory for repairs. It seems that the light meter had quit; when he took the camera to the local franchised nationally-known photography shop, where he had purchased the camera, the salesman told him that he must have dropped the camera and that it would have to be fixed, probably at considerable expense. When my friend showed me his camera, which was empty, I opened it, used a penny to unscrew the little cover on the battery receptacle hidden away inside the body, and out dropped the tiny battery which was about the size of three dimes piled up. A touch of the electrodes by my tongue disclosed that the battery was dead (no tingle on the tongue). On the way back from lunch, we stopped off at the drugstore, bought a new battery, and he was back in business.

This battery business is particularly important when operating an automatic, or "coupled" camera, in which not only the light meter but the actual camera settings are adjusted by electric power supplied by batteries. If you are looking at a used automatic camera, be sure that you know where *all* the batteries are, and how to change them. Remember, if a light meter battery goes flat, you can still use the film package directions, but many of the automatic cameras, even in manual mode, depend on strong batteries to operate the shutter. If batteries in those cameras go dead, the works won't work. Ask the clerk about that concerning your selection.

Before you leave the camera emporium, buy an ultraviolet filter and screw it into the threads on the front of the camera's lens. It will protect the lens and is the single most valuable filter for aerial photography, either black and white or color.

Chapter 8
A Discourse On Film

When it comes to making a choice of film to put into one's newly acquired 35mm camera, a certain amount of confusion ensues, for the film racks in any camera shop are filled with dozens of little boxes of various hues and makes and most people don't want to look stupid when making a selection. If a new camera owner does work up the nerve to inquire what to put into his equipment, he may find himself further confused by terms such as emulsion, grain, resolution, speed (there's that word again!) and latitude. After his ego has wilted under the deluge of un-asked for expertise, he usually says "Give me a roll of color film," whereupon a new level of total confusion arises when the salesman smilingly inquires, "Color reversal film, or color negative film?" It is sometimes my impression that some people are just natural-born sadists. Film is not all that complicated.

FILM IN GENERAL

Three types of film, speaking in broad terms, are available for all 35mm photography. The first type is black and white (B&W); the second two are both color films, but work differently. They are known in the trade as (a) color negative and (b) color reversal films.

B&W film is so simple to process that it can be done by anyone who takes the time to learn the procedures; in fact, one does not even need a darkroom. My son Greg, who has been both a pilot and a camera-bug since his late teens, used to sit in the living room watching television, both hands buried in a black, light-tight bag containing a stainless steel developing tank and his most recently

exposed film cassette. As reflexively as someone knitting, he was changing the film from the cassette into the tank, winding it onto the circular development rack, pouring developing fluid into the tank, then closing it and agitating it (photographic lingo for shaking it to slosh the developer on the film). After a given amount of time, as established by the developing directions, he would dump the developer, replace it with another chemical that would stop the development, then within a few minutes, dump that "shortstop" out and flush the little container with clear water.

Then, after it had dried by hanging it in the powder room (which used to drive my wife up the wall) he could run the negative film through an enlarger and "blow up" the little negative images to positive enlargements, as large as 8 × 10, sometimes to 17 × 22.

I have used this terminology so as to lead in to a discussion of how a film works to produce a picture. The first step is to explain some of the terms you hear and read about.

THE NEGATIVE

In photography, the word "negative" signifies tonal opposites: a photograph of a house in wintertime against a background of snow covered ground and bare trees will be seen in a finished B&W print as a series of gradations from black (the bare trees) through a series of grays (the house, its roofline, the sky above, a walkway) to white (the snow). The negative, (i.e.: the developed film, from which the print or enlargement is made) will show the trees as white and the snow as black, etc. The lighter parts of the negative have allowed more light from the printing (or enlarging) light source to reach the printing paper, which is also covered with an emulsion and must be chemically developed. Which brings us to the question, what is an emulsion?

EMULSION

An emulsion is a gelatinous covering applied precisely to what is called a "carrier," either a film or a stiff piece of paper. Since we are going to discuss films, let's put the paper, which is used for the prints/enlargements, aside; any photography shop has literature about that.

A film's emulsion is applied to a celluloid carrier like a coat of paint on a roller window shade. The emulsion contains light-sensitive chemicals, principally silver, which are activated, first by exposure to light, then by the application of a developing solution to produce the working negative from which the print or enlargement is eventually made. The silver is carried in the emulsion in the form of tiny

metallic flecks, literally grains. These silver grains are chemically the key to photography.

GRAININESS OF FILM

If you visualize sand—fine grain sand and coarse grain sand—you can understand the term "graininess," because that is what the siutation is, except that the grains are metallic silver. The size of the grains determines the sharpness of the image structure when the film is processed. When the silver grains are fine, the film "grain" is "fine" and a sharp image will result with small losses of definition in the enlargement, for of course the grain is enlarged, too. Conversely, when the grain is "coarse," the image reproduced is likewise coarse with a correspondingly greater loss of both detail and definition. The image, when greatly enlarged, may look fuzzy, or, to use the photographic term, "grainy." Graininess becomes apparent as the negative image is enlarged; it does not matter much on contact prints (so called because the negative is pressed against the print paper on a 1:1, no-enlargement reproduction), but since the 35mm negative is so small—about the size of a postage stamp—it must be enlarged to be enjoyed.

RESOLUTION

A film's resolving power refers to its ability to capture and reproduce the smallest detail in the photo. Again, this is a function of graininess: the finer the grain, the greater the resolving power, hence the cleaner the details seen in an enlargement. So the answer would seem to be to use fine grain film all the time, right? Not always. Here we get back to "fast" vs. "slow."

THE "SPEED" OF FILM

For technical-chemical reasons that we need not go into here, fine grain film requires more light than coarse grain film to activate the silver, therefore it follows that coarse grain film is "faster" than fine grain film, which is in turn said to be "slower." New members of the photography club may follow the theme that the-fastest-is-the-bestest and go for high speed film with high ASA ratings, thereby doing themselves an injustice. For taking aerial photographs in broad daylight, you do not need *fast* films any more than you need *fast* lenses or *fast* shutters.

Film speed, properly referred to as the relative sensitivity of the emulsion to light, is calculated scientifically just as exposure-producing apertures and shutter speeds are, with their sensitivity rating being established on a scale of values. In the United States the

scale bears the name of "ASA rating" as set by the American Standards Association, now called the American National Standards Association. Sometimes the camera or light meter will carry both the ASA scale and another, usually DIN, for Deutsche Industrie Norm; BSI, for British Standard Institute; or JSA, for Japan Standards Association. You may also read or hear of Weston scales and Scheiner scales, but you can forget them. In the U.S. market, we work with the ASA ratings.

Of the B&W films, Kodak Panatomic X has an ASA of 32 and Tri X Panatomic's ASA is 400. By using Tri X it is possible to take available light (i.e.: no flashbulb) photos by candlelight, because it *is* so fast. Using Panatomic X for the same picture would be a waste of film.

On the other hand, in bright daylight, Panatomic X will produce a sharp, high resolution negative because it is so fine-grained. As in the case of the tortoise and hare steeplechase, sometimes slow speed wins out.

Between the two films just mentioned, Kodak has two more films: Verichrome Pan and Plus X Pan, both with ASA 125 ratings, about the same as used in their Pocket Instamatics. For all I know, it is the same film, cut to different dimensions. I use Panatomic X and Plus X for my air shots from time to time, but seldom have the urge to buy Tri X.

PANCHROMATIC FILM

While we are on the subject, I might as well say a couple of words about B&W film types and get it over with.

A number of years back we used orthochromatic film for virtually all B&W photography (fact is, there was no color film then). Color renditions, achieved by various delicate shadings of gray, had the peculiarty of reproducing red as dead black, since the film was insensitive to red. Wizards of chemistry in the film business then achieved a breakthrough and made red-sensitive films, which required a new name. The word orthochromatic, derived from the Greek means straight (ortho) colors (chromatos); now they juggled it around and introduced a new Greek word, "pan" which means "all;" the result was orthopanchromatic which loosely means "it gets *all* the colors and gets them straight." For years we talked about "ortho" film and "pan" film; now that orthochromatic is kaput, we use all of the later kind, calling it simply "panchromatic," or using "pan," as a prefix: *pan*atomic and *pan*chro-press.

LATITUDE

The term "latitude" as used to describe the characteristics of film, as in "It has wide latitude," indicates that a little imprecision in

setting the exposure will not materially affect the quality of the picture. Some narrow-latitude films are so sensitive that opening the aperture one stop too much or too little, or not changing the setting when a cloud goes over the sun, will mess up the exposure. Most of the film generally available in photography shops for general use have, as you might suspect, wide photosensitive latitude built in, so they will take such variations of light in stride. Many photographers intentionally underexpose one stop to darken the sky, both when using B&W and color. The exposure may not be precise, but only the most practiced eye will know it.

As a tag to this section, it may interest you to know that, generally speaking, the faster the film (emulsion), the less margin for error; the slower the film, the greater allowable margin for error. Or, as photographers say, the greater the latitude of the film.

B&W FOR AERIAL USE

Any good, fine grain film will make excellent photos either on the ground or from several thousand feet above it. There is, however a problem to be considered from the outset: black and white photographs, particularly 35mm negatives for black and white photographs, must be chemically processed (developed), then enlarged. The normal 3 × 5 enlargements (commonly mistakenly called "prints" because they are the same size of contact prints made from the old Brownie-type cameras) simply must be further enlarged to be worthwhile as aerial shots. A 3 × 5 print of Manhattan Island from 5,000 feet is interesting, but when it is blown up to 17× 22, it becomes *impressive*. If you are going to use B&W, you will have to give some thought to enlargement equipment, which means investing in a darkroom.

The major drawback of B&W for aerial shots is that, unless you have your own darkroom and the training and equipment to process your film—and enlarge the images precisely as you want them—or have available a photo-bug friend who, as a competent darkroom operator will, perhaps for a fee, perform the critically precise work required to achieve the desired results, you may be grievously disappointed. It has been my experience that B&W exposed films of aerial shots reflect the get-'em-in-and-get-'em-out techniques of those high-volume centrally located commercial development laboratories. By their very size and mass production techniques, geared to the on-the-beach snapshot type of pictures, they will not treat precious aerial shots with tender, loving care. You may have purchased the best fine grain film, made perfect exposures with a sharp lens, yet wind up with a greyed-out photo, which is worthless.

It may be because the developing solutions have broken down or that the development-shortstop-wash-dry cycle has been interrupted. In any event, if the negatives are ruined, they are lost forever. I know: I have had that experience several times putting pictures together for this book.

There are, however, certain advantages to black and white film. For example, once developed, it can be used by anyone who has a darkroom to make a series of contact prints as test strips; these may be examined under a magnifying glass for details, then the better ones can be enlarged to produce a large sized quality photograph suitable for framing. If the film is good, the exposure on the money and the processing is done correctly, there is almost no limit to how large a 35mm negative can be enlarged, right up to photomural size.

Without a darkroom, there is another choice: color film.

COLOR FILM, GENERALLY

Color film, like B&W, has an emulsion but with a major difference: whereas B&W has a single homogenous layer on the film base, color film has three carefully applied layers. The front layer or top layer (the one closest to the lens) is sensitive to light blue, only. Beneath that layer, a thin layer of yellow die is laid which prevents blue light from penetrating any further, as will be explained in a moment. Below that is a layer sensitive to blue and green, except that the blue light is held back, or filtered out so that only green light penetrates that far. The last layer, next to the film base (the carrier) is a layer which is sensitive only to red. When the multi-layer exposed film is chemically developed, the yellow dye washes away, leaving the activated color layers to react to the chemicals. Before we go any further, let's go over the theory of color.

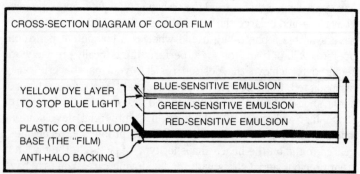

The cross section sandwich of emulsions on color film. All of these are crowded into less than 1/100th of an inch!

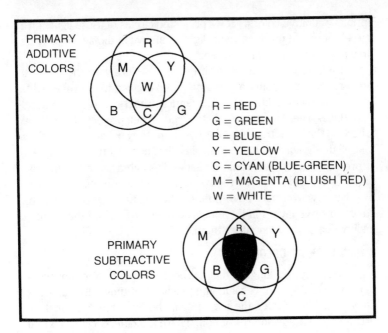

Primary additive and subtractive colors.

COLOR THEORY IN A NUTSHELL

Books have been written on color theory and the physics of light, but it will be enough for our purposes to hit only a couple of high spots to help understand both color photography and the way photographic filters work, which will be the subject of the next chapter. Both are interrelated.

What we call light is a form of energy. Pure white light from the sun is created by a totality of energy waves, only a few of which are visible to the human eye, all mixed to form what we call "white." At one end of the visible spectrum is violet. At the other end is red. Between them are indigo, blue yellow and orange. Beyond violet is a form of light invisible to the human eye: ultraviolet, which is nevertheless picked up by the emulsion on film; we say that the film is sensitive to ultraviolet. Beyond the red end is another color invisible to the human eye: infrared.

PRIMARY COLORS, ADDITIVE AND SUBTRACTIVE

Three colors can be projected as light and mixed to produce nearly every color the eye can see in nature. They are cherry red, green and blue-violet. Because they can create all colors when projected, including white light where they overlap, they are called

"primary additive colors." If we projected circles of these lights on a screen, it would produce visual light as shown in the accompanying drawing, Primary Additive Colors.

However, there are also three other colors with the physical properties of removing a primary additive color from white light: yellow subtracts additive blue, magenta subtracts additive green and cyan (blue-green) subtracts additive red. When projected together, where all three subtractive colors overlap, they produce black: they take all the light away, hence are called "primary subtractive colors." In projected light, they would appear as illustrated in the accompanying drawing, Primary Subtractive Colors, on a screen.

By now you may have noticed the relationship between the color-sensitive layers in the emulsion of color film and the primary additive colors, which affect them.

A NEW LOOK AT COLOR FILM

Generally speaking, all that has been said about black and white film, as regards grain, resolution, speed and latitude, also applies to color film. The slower the film speed, the finer the grain and the greater the altitude and resolution. There is a difference however in the results you get from the processing lab: some film, called color reversal film, produces transparencies, or slides. The other type, color negative film, produces "prints" (as I said before they are really 3 × 5 enlargements from the 35mm negatives). Why and how? Lemme 'splain.

COLOR NEGATIVE FILM

When color negative (print-producing) film is exposed and developed, the colors on the processed negative are just the reverse of what we perceive in nature. A picture of a red rose against a green bush and blue sky will be seen, if you hold the negative up against a light, to be a blue-green (cyan) rose against a magenta bush and a yellowish sky. But, if those "negative" colors are projected in color sensitive enlarging paper, the process is reversed and the correct "natural" colors emerge on the prints or enlargements. It is a two-step process, just as in the black and white image transference technique. Few people except photographers call them color negative (actually they are negative color) films; they simply ask for "color print film." It must be noted that color negatives can be directly enlarged on black and white photo enlargement paper.

COLOR REVERSAL FILM

Photo-chemistry, having discovered how to create a three layer sandwich of emulsion on film to create sensitivity to primary

colors, developed a system whereby the subtractive colors appearing in transparent 'negative color" negatives, also developed a way of causing the colors in the emulsion itself to reverse chemically to produce additive colors so that, after processing, the film could be either looked at against a light or be projected on a screen in full, living color. Because one could look through it and project through it, it was called a transparency. To make viewing easier for the customer, the processors cut the individual frames from the film, mounted them in little two inch square cardboard holders for individual projection, and they become known as "slides." Hardly anyone ever asks for color reversal film nowadays; they just ask for "slide film."

WHICH IS BETTER?

Both color negative and color reversal films are excellent. Most of the time, I use slides, because they have such visual impact when projected on a high quality screen. My wife prefers color prints which she can paste in an album. However, when I agreed to use color negative films one trip, I promptly learned a lesson: the prints were looked at, then dropped in a drawer somewhere. No album. What was worse, the negatives—the color negatives—soon became separated from the prints (enlargements) and they are not very hard to lose; usually they come back from the processing lab cut into four inch lengths, just about the right size for bookmarks. As in one of my wife's cookbooks. So, it has been back to the transparencies again for recording the journals of Smithair.

HOW FAST A FILM?

The first slide film we used was the old Kodachrome ASA 10, used in an ancient Argus 35 mm, a fully-manual type of camera. Not only did I have to set the shutter speed and the aperture, I had to reach down and manually cock the shutter by pressing a little lever on the front of the camera's lens assembly before I could take a picture. To move the film, it was necessary to twist a knob on the top of the camera; film-transferring cocking levers had not been invented, yet. Nor did I have a light meter; that was the camera that started me using the little line drawings on the sheet of directions in the film box.

The pictures I took with that camera, crude as it was by today's standards, were—and still are—great! They weren't works of art, but their colors still stand out 20 years after they were taken and when they are seen on our large glass-beaded projection screen, I feel as if I am right there again in Florida or on Cape Cod or flying my

little Cessna 140 over Philadelphia. I do not know what kind of lens was in that camera, but I will bet it was pretty simple, probably an f/5.6, uncoated and, as I recall, with a big bubble in the glass. No matter. It gave me good pictures, until I got the urge to move "up" and traded it in.

The old ASA film was warm, the colors bright and there was so much latitude that everything seemed to come out just fine. Of course, all of those pictures were taken in good weather, usually between 10 a.m. and 3 p.m., because that was when I flew.

My second camera was a Voightlander Vitessa which could slip into my hip pocket; the lens assembly retracted and was covered by a pair of folding doors, which made it a flat package and was extremely handy in the Comanche we were flying at that time. The guy I bought it from also recommended that I stop using that "slow" Kodachrome 10 and move up to Ektachrome, which was three times as "fast." Being new at the game, I bought several rolls to record our next trip to Florida and the Bahamas.

It didn't take long to realize that the "fast" argument didn't carry any weight, because I was closing down the aperture to compensate for it, anyhow. When we got the transparencies back, there was an over-all bluish tint which was completely different from the warm colors of my old Kodachrome 10. Y'see, no one had told me about filters, yet. All my pictures were taken with a nekkid lens. We will get into that in the next chapter.

Widely Available 35mm Films Color

Name	ASA Rating
Negative Color (Prints)	
Agfa Color	80
3M	80
Fuji Color	100
GAF	80
Kodacolor II	100
Kodacolor 400	400
Color Reversal (Slides)	
Kodachrome 25	25
Ectachrome daylight	50
Kodachrome 64	64
Agfachrome	64
3M	64
Ectachrome X Daylight	64

3M High Speed	100
High Speed Ectachrome	160
Ectachrome 200 Daylight	200
GAF Color Slide	200
Black & White	
Kodak Panatomic X	32
Plus X Pan & Verichrome Pan	125
Tri X Pan	400

Now, we have all kinds of choices of color films, for both slides and prints. For the former the ASA ratings range from Kodachrome ASA 10 up to Ektachrome ASA 200; the range for prints is between ASA 80 and Kodacolor 400, which makes indoor shots of night club shows possible (if they don't catch you taking them).

I have had excellent success with the Kodacolor II for slides (ASA 100), except when I lose the negatives as bookmarks, but my preference has been for slide-producing Kodachrome 25, until recently. Tony Linck, one of, if not *the* leading aerial photographer in the New York area, told me that the Kodachrome 64 is just as warm as the 25 (which I have always felt was as warm as the old Kodachrome 10) and to go ahead and use it. My next trip will be my first real pass at that film.

A FINAL WORD ABOUT FILM

It is not really necessary for those of us who are not professional photographers to pre-purchase a great deal of film before taking a trip, especially to a foreign country, where anyone toting extra film is considered suspect. One of the charms of 35mm photography is that film is available almost everywhere, from the Frozen North to the Sunny South.

However, if you plan to take a *whole lot* of pictures, you can save money by buying film in bulk. Remember the word "sleeve." We used to purchase 35mm film cassettes in cartons, two dozen cassettes at a time. Using 36 exposure cassettes, we had a stockpile of 864 exposures available. Today, instead of cartons, film can be now bought in groups of 24 wrapped tightly in saran-wrap. The question is: How much film do you really need? That many 20-exposure cassettes contains 480 exposures which figures out to an average of 68 pictures a *day* for a one week vacation trip. But, film cost is by far the cheapest item on such a trip, and it is always better to have too much than none. The *National Geographic* layouts are the quintessence of hundreds of photographs taken for each story, shot from

different angles with different exposure settings and filters. Not even the best photographers take excellent pictures every time the shutter clicks.

FILM STORAGE

Whether you buy film, especially color film, by the sleeve or by the cassette, remember that the emulsion's worst enemy is heat. Never, *never*, *NEVER* leave a loaded camera or any film, exposed or unexposed, anyplace where it will be heated more than 80°F. (26½°C.) This includes the inside of an automobile or an airplane standing under the hot sun, whether or not the camera/film is stashed away in the glove compartment, luggage space or under the seat. If the emulsion soaks up heat and softens, it will be ruined; remember those three microscopically-thin layers of color sensitive emulsion on color film.

Experienced photographers store film in a refrigerator where it is not quite freezing, because film will retain its color sensitivity for years under that temperature. My wife complains once in a while when she finds a couple of rolls tucked away behind the egg basket in our home fridge. One night, while socializing with Marie and Tony Linck, my wife raised the question about what he, as a busy professional photographer, did about film, which made Marie almost fall out of her chair, laughing. Tony marched me to their kitchen which had a pair of refrigerators: one was full of food, the other was full of film. I think he must buy film in carload lots.

Since it is not always feasible to carry 24 little boxes of film every time we leave the airplane for a few hours, as when acting like tourists on a stop en route, we began a few years back to carry a styrofoam ice bucket in the airplane. With a handful of ice cubes, there was still room enough for a dozen cassettes of film, removed from their cardboard containers, but left in their water-tight cans. Since that worked so well—we haven't lost a film to heat since we started our ice box ploy—we have since then enlarged to a full-sized portable ice chest which we load up wth apples, oranges, sandwiches, cold drinks and cheese for noshing while on those four and five hour legs when heading for the far-off places. And film.

Another hint: always have color film processed as soon as possible after it has been exposed. The exposure itself is the first step of development and delay can result in deterioration of the chemical reactions this initiated. Don't leave a partially exposed film in the camera for a couple of months, particularly if you have taken some pictures that may be unforgettable in the early part of the roll. It pays, sometimes, to waste the tail-end of a roll rather than to lose exposures already made.

A WARNING ABOUT PROCESSING

A word of caution from one who has learned the hard way: if you shoot up a number of cassettes of film on a trip, do not take them to the corner drugstore or to a place that advertises 24-hour processing. If you use Kodak films, for example, take them to a shop that will send them to a Kodak processing laboratory. It may take a few days longer to get them back, but it is worth it, for the same reasons mentioned about the lack of tender, loving care of the high-volume processing centers that run all kinds of films of various manufacture through the same developing baths.

Second, even when you have the films processed by a high performance lab, don't—repeat, don't—drop them all off at one time, for even the best labs will have problems once in a while. We lost six rolls of film taken on a trip to Barbados to such an incident; when we received them, the only color was blue—they were blue and white transparencies, accompanied by a note of apology and six rolls of film in replacement. Obviously, they could not replace the actual scenes of blue skies, pastel colored houses, palm trees and white beaches. Since that incident, we have always fed the film to the lab on a one-film-at-a-day rate, so that if one of those rare laboratory malfunctions does happen, we won't be wiped out again.

FILM CHOICE: BLACK AND WHITE, OR COLOR?

Most of us use color film in preference to B&W, if for no other reason than that it *is* color. When we throw an image on the screen of a tiny airstrip on Baja California or a remote settlement in the Bahamas, or ancient Indian ruins, in our hearts and minds we feel the warmth, feel the pneumatic bumps of flight, hear the engine; once more we dance the skies on laughter-silvered wings. Which is the reason we take the pictures in the first place.

Chapter 9

The Filter Factor

Our number one enemy in aerial photography is haze. Few people who do not fly have any concept of haze, but as a pilot you know that haze exists even on those clear winter days when the air seems crisp and clear; after climbing to three or four thousand feet, we rise out of the thin milky layer into the true clear blue of the sky. In the summertime, when the air is warm and will hold more moisture, the haze level sometimes rises to eight or nine thousand feet. In either case, it is called ground haze, because it goes right down to the ground.

Ground haze, which is really a light fog, exists to some degree almost everywhere except over arid areas and tends to build up more near moist localities, especially around swampy ground, lakes, rivers and oceans, where the sun sucks up water vapor which mixes with dust particles. The situation is worst around large cities where the air is full of hydrocarbon particulates from combustion: auto exhausts and smoke from factory chimneys, a sooty by-product that combines moisture to form "smog" (smoke + fog) or "smaze" (smoke + haze). Anyone who flies around the East Coast between Washington and Boston deals with smog regularly, and knows that when the weather briefer says visibility is up to 15 or 20 miles, it is considered a "clear" day. It is only when one flies over the great Southwest, where the skies are not cloudy all day, that the weatherman will advise "visibility better than 70 miles," or "CAVU"— ceiling and visibility unlimited—or "CAFB," which you will have to figure out for yourself.

TYPES OF LIGHT

Three sources of natural light come through the lens to activate the emulsion on film. The first one is sunlight, pure white light from the sun's direct rays. The second is reflected light, bouncing back from buildings, trees, highways, runways, beaches, snow covered slopes, the tops of clouds and the ground itself. The third is *sky* light, which is a combination of the direct light from the sun, diffused by the atmosphere, plus reflected light from all other sources enumerated above. Both direct and reflected sunlight illuminate particles of dust, particulates and moisture floating in the air, which creates what photographers call "incident light." The diffusion of sunlight, both direct and reflected tends to make the sky look pale, instead of deep blue. Sometimes it looks milky. What is happening photographically, is that many unwanted colors, some of them invisible to the human eye, are pouring on to the emulsion every time the shutter opens and closes and adding their impact to the silver's reaction to the exposure. What really happens is that the film is fogged by the excess light, making the end result a "muddy" photo instead of a clear reproduction.

Fortunately, for moisture-type haze, we have a countermeasure called the lens filter. Unfortunately, for those of us who aviate mostly east of the Mississippi River, no filter will cut through industrial haze, smog and the great mounds of automobile exhaust that rise over all big urban areas. It is not moisture; it is soot plus moisture.

Professional photographers use filters as a matter of course, but relatively few rank amateurs do because they seem so, well, mysterious. What in the world can a little piece of red, yellow or orange, or some of the seemingly clear glass, mounted in rings, do? Believe me, they do wonderful things for both color and for B&W. Not only that; filters are easy to use and a few—maybe three or four—will do just about everything you might want, both for color and for B&W. Let's talk about color photography, first.

FILTERS FOR COLOR PHOTOGRAPHY

Three filters will do it all if all you plan to shoot is color film, whether transparencies (slides) or color negative (prints): (1) an ultraviolet filter, called a "UV" filter; (2) a "skylight" filter and (3) a polarizing filter.

The ultraviolet filter, although colorless to the human eye, which is to say that it looks like a piece of clear glass, nevertheless has the ability to hold back, or screen, an equally invisible color, beyond the blue range of the visible spectrum. By holding back,

screening or filtering the ultraviolet rays, the UV filter eliminates them from the incident light passing through the lens, thereby inhibiting fogging due to excessive exposure, a condition also sometimes known as "hazing," but allows the reflected light of the sun to come back from the objects being photographed. Thus, it is a "haze cutter."

The skylight filter has a slight tint to it and is sometimes used in lieu of the UV because it has the ultraviolet screening ability, plus one other. Remember how my first efforts with High Speed Ektachrome disturbed me because they did not have the warm colors of the old Kodachrome 10? What had happened was that the film was more sensitive to the blue end of the spectrum, so that the blue light of the sky created a bluish tone out of the direct sun, as when photographing an object in shadow. From the air, every shadow on the ground had that blue cast. Simply by using a skylight filter, I could have eliminated all my problems, and so can you.

Best of all, both the UV and skylight filters (one at a time, of course) can be screwed on to the front of the lens and left there all the time. The UV can be left on, even if you are using color and B&W interchangeably. I always have a UV on my lens, to protect it from dust, dirt, and finger smudges.

The third filter used for color work is the polarizing filter which has the property of removing glare from reflections under direct sunlight, from such objects as glass, chrome surfaces and water. Fishermen have used polarizing sunglasses for years, because such spectacles enable them to see fish beneath the surface of a trout stream or a bone fish bank in the Florida Keys. Polarizing filters for our cameras have an additional advantage: the piece of polarizing glass that aligns the wildly vibrating light rays from a shimmering surface into a single plane of vibration, as the fisherman's Polaroid sunglasses do, is set into a filter ring that can be rotated to achieve all sorts of effects. A few years ago, we had to engage in some computations to figure out what the most effective plane of polarization would be for a picture, but now, with a SLR, we can actually *see* what the rotation of the lens will do to cut down glare *and* to make the sky look bluer, which in turn makes the clouds look whiter. And that is about it for color film.

FILTERS FOR BLACK AND WHITE FILM

For normal use, tinted or colored filters are used for black and white photography to achieve several different results. The UV filter is still appropriate, of course, for it eliminates the passage of ultra-

violet rays which affect the B&W film as they do color film. However, B&W inherently has some other problems.

The major problem is that "color" is represented by shadings from pure white to dead black, mostly delicate shadings of grey. What we have to do is *think* color, while working in black and white. How do we go about enhancing a color so that it will be more striking on a black and white print or enlargement. Back to the theory of primary additive and primary subtractive colors.

COLOR THEORY, REVISITED

Remember that three primary additive colors, cherry red, green and blue-violet can be mixed as colored light to produce all of the colors seen in nature? And that each of the three primary subtractive colors, yellow, blue-green and magenta, has the physical property of removing one color, pure white light? This in optical physics is called selective absorption, and in B&W photography, this is how it works:

A yellow filter on the front of the lens will hold back, screen, absorb, filter—all those words mean the same thing—the blue light selectively from the white light (daylight/sunlight) yet allow the other two primary additive colors to pass through, green and red. The silver in the film's emulsion is activated or affected by the green and red, but not by the blue, since no blue is hitting the film. As a result, the bluest part of the image on the exposed film, i.e., the sky (or the sea) is relatively unexposed and remains less developed, or clear after processing. Then when printed (or enlarged) on photosensitive paper to make a print or enlargement, more light goes through the underexposed film area, while the green/red combinations have darkened the negative and allow less light to pass to the printing paper. Thus, when the negative image is reversed to form a positive in shades of gray what was light (because of the filter) on the negative prints out to be the dark part of the positive, i.e.: the print. The darker the yellow of the filter, the darker the sky will appear in the finished B&W print.

FILTERS TO USE

For black and white photography, particularly from the air, four filters should be considered:

 (1) the ultraviolet (which is always good for cutting haze);

 (2) the medium yellow, which will render a slightly-darker-than-normal sky, making clouds appear where a photo without a filter would be washed out and blah;

(3) an orange filter, which has more punch than a yellow filter and emphasizes the blue sky and clouds and is the filter to have if you are going to have only one, and

(4) a light or medium red filter, for special effects which you may not really be interested in for a while.

PRACTICAL APPLICATIONS

Most people start off with the yellow filter, usually of medium density, because it does snap up the sky and the blue of the ocean by darkening them somewhat in black and white photographs. I advise that you don't fool around with the red filters, for even the lighter colored reds are dramatic enough to make a daylight flight in towering cumulus clouds look like a moonlight flight. If you watch old moving pictures on late night TV, especially old Dorothy Lamour or Betty Grable shows featuring tropical scenes at night, you may note that shadow patterns are clear. That was a regular technique in Hollywood's black and white era; they would shoot the scene in daylight, clamp a red filter on the camera, and voila! Night scenes.

Tony Linck uses nothing but orange filters on his B&W aerial shots, when he uses a filter at all. Frequently he achieves darkened skies in air to air shots by underexposing the film then overdeveloping it in the darkroom. Taking a leaf from his book, I recommend the orange filter too. If you realize that orange is a mixture of yellow and red, its complementary color, the one it will subtract from basic white will be a medium blue, so that the sky effect would be more than the yellow filter, but less than the red. To put it another way, it is just about perfect for taking air shots in B&W of sun drenched islands set in the ocean, like the Bahamas.

FILTER FACTORS

Because filters absorb some of the incident light before it reaches the film, the intensity of the light is reduced, even that light which "passes" the filter, hence a greater exposure time is sometimes required to balance the exposure, just as if a cloud went over the sun. The amount by which the aperture must be opened to make this adjustment is called the "filter factor," which is printed on the directions that come with the filter, and in most photography manuals.

Because they are so clear that they do not hold back visible light, the UV and skylight filters have a filter factor of 1, hence do not require any change in aperture.

However, when you begin to use yellows, oranges and reds, all of which come in various gradations of color, some adjustment must

be made. In cameras where the light meter "reads" through the lens, the lens + filter will cause a different reading from the lens alone, so it is just a question of setting the aperture as the built-in light meter indicates. Without this feature, the photographer must reset the aperture in accordance with the filter factor. A filter having a factor of 2.5 requires a 1½ stop change, which usually works out to a two stop change, since underexposure helps to darken the sky. A light red filter has a filter factor of 7, about the darkest useable with black and white film. (The dark red filter is used with infrared film, a technique all its own.)

And that is it about filters.

Recapitulation on Filter Factors

Filter Color	Filter Factor	Darkens	Lightens	Reason for Using
Pale Yellow	1½	Blue	Yellow	Moderate Cloud Effects
Medium Yellow	2	Blue	Yellow & Blue	Stronger Cloud Effects
Dark Yellow*	2	Violet & Purple	Green	Forests, Grass Fields
Orange	3	Blue & Green	Yellow & Red	Dramatic Sky Effects
Light Red	7	Blue & Green	Orange & Red	For Very Dramatic Sky Effects
Ultra-violet	1			Haze Cutter
Skylight	1			Cuts bluish cast
Polarizing	1			Cuts out glare in incident light and from reflective surfaces

Filter Factor Settings

If the Filter Factor is →	1½	2	2½-3	4	6	7-8
f/5.6	Br*	f/4	Br	f/2.8	Br	f/2
f/8	Br	f/5.6	Br	f/4	Br	f/2.8
f/11	Br	f/8	Br	f/5.6	Br	f/4
f/16	Br	f/11	Br	f/8	Br	f/5.6

And the normal f/ stop setting is →

*"Br" = "Bracket." Try to shoot between the higher and lower stops adjacent.

(Bracketing f/5.6 and f/4 results in an opening of f/4.8, for example.)

Chapter 10
Airplanes, From The Inside—Out

Arguments have been waged for years concerning which type of airplane, high wing or low wing designs, are best for aerial photography. Fact is, it doesn't make a bit of difference; high wing, low wing or bi-wing, any airplane can be used. As long as the exposure is right, a good picture will result of whatever the camera is pointed at. Unfortunately, many of my early efforts from the Cessna 140 and the 182 have some features on the ground obscured by wing struts or fat little tires on the landing gear hanging a few feet below the window. Then, when we moved into the low wing Comanche, we always seemed to have part of a wing somewhere in the finished photo. Over the years I had noticed that the superlative photographs in top quality aviation magazines and air shots in the *National Geographic* seemed to be taken from a wingless camera platform, possibly a free balloon, for they never seemed to have any tell-tale parts of the photo ship showing in the picture. What the professionals do, of course is take their pictures at an angle out of the airplane that avoids including the wingtips, struts or elevator surfaces, by various means, including remote camera locations, such as extension mounts from helicopters. Such techniques are beyond most of us, so I am satisfied to have some part of my airplane showing, especially when using a wide angle lens.

Another argument you can find yourself in is whether or not to shoot through windows (of course we are talking about clear windows. Tinted windows raise hell with air shots, especially color photos). The point was raised to me one time when we were hiding

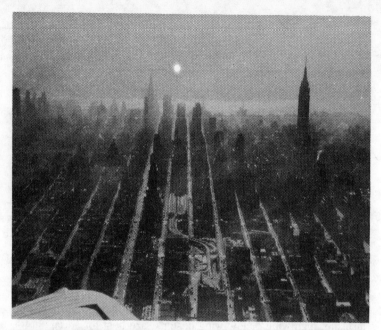

This photo was taken by Tony Linck through the window of a Swift (note characteristic slotted leading edge of wing showing at bottom left) on a hot, sultry summer, shortly after noon. From 1,200 feet individual automobiles can be seen in the streets, but New Jersey is wreathed in smog beyond the Hudson River. People on the ground thought it was a clear day! (Tony Linck photo)

from the Middle Atlantic Winter on one of the Bahamas Out Islands, called Normans Cay.

While soaking up sunshine on a beautiful snow-white beach adjacent to the 3,000-foot long airstrip, I saw a flock of Piper airplanes circling to land. When they rolled up to the nearby ramp, I sidled over to say hello, since I figured it was some of the gang from the Vero Beach plant where my son Doug used to work.

The first thing I noticed was that all the airplanes had new paint schemes; the second thing that caught my eye was that there were two Cherokee Sixes; the one with the current year's colors had both the right front door and the rear door and baggage hatch on the left rear side of the plane removed, leaving yawning holes. As I strolled closer, I saw that the doorless Cherokee Six was full of camera equipment. Of course, it was a special photo job for the next annual product brochure taken against a background of blue skies and tropical islands set in shimmering blue water. Edging up to the photo plane, I inquired why the doors had been removed.

"We always remove the doors or windows because we lose so much quality if we shoot through the plexiglass," explained one of

the cameramen. "Sometimes, we have special airplanes with optical-glass nose or tail cones, for some special head-on or over the tail shots, buy we try to avoid taking pictures through the windshield or side windows whenever we can."

In the next few weeks, when we returned to the frozen north, I had occasion to talk to several famous photographers about this business of removing doors and/or windows, versus shooting through the plexi. Their answers were all the same: for a commercial photo mission, they frequently removed plexiglass, but most of the time they just shot right through it, and it took a real expert to tell the difference. Tony Linck, a former LIFE magazine staff photographer who had developed a tremendous reputation as a commercial aerial photographer, told me that he made a concession to photographic purity by having the so-called storm window from an Aero Commander installed in the left window of his own Mooney Mk-21; the Mooney's normal storm window, like those of the Comanche, Apache, Cherokee and others, is quite small, compared with the one they put ln the Bethany Bombers. When Tony has an air to ground commission, he opens the giant side window and lets 'er rip with his Canon 35mm camera.

A few years ago Jim Yarnell, resident photographic genius for the Beech Aircraft Corporation—and who takes those sensational air to air shots of Beech airplanes for brochures and advertising

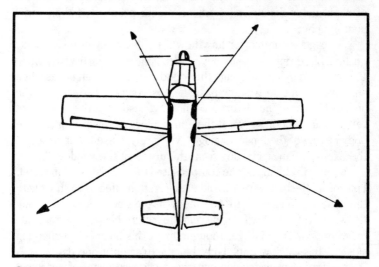

Clear fields of view from either a high wing or low wing airplane require shooting through the plexiglass windows at an angle. However, it is more interesting for most of us to show a wingtip or part of the cowling in our air shots, for it helps to identify the airplane.

layouts—collaborated with the well known writer Martin Caiden on a book to introduce the then-new Beech Debonair. With "Debbie" as their steed, Marty and Jim flew a lengthly trip, hop-scotching the United States from sea to shining sea, all photographically documented by Yarnell's taking pictures at a rate that made the camera too hot to hold. Obviously, they did not remove doors and windows on that promotional trip, but Jim shot thousands of pictures right through the plexiglass. The original deal was for one book by Caiden, illustrated by Yarnell's photos. The pictures were so wonderful that a second book, entitled *This is My Land* also was issued, featuring the photographs. So, it is not a hard and fast rule that windows have to come out or doors off.

THE WINDOW PROBLEM

Speaking in terms of photographic purity, whenever light passes through any kind of glass, even clear glass (tinted windows are a real problem!) a certain amount of it is taken away by filter effect. Because plexiglass is easily bendable, there is also bound to be a bit of light ray (and image) distortion, as well. Worst of all, as airplanes become older and more used, their soft windows begin to show the ravages of time. Blowing sand, poor cleaning techniques, oily films from jet engines at busy airports, ordinary dust and dirt, bird droppings and those inevitable internal stress marks that come with age of plexi under flexing, all of these create problems for an aerial photographer.

Plexiglass, no matter how new it is, is usually of poor optical quality. Little ripples create havoc with light rays, particularly when the camera is pointed through the window at an acute angle, as when shooting out a side window past the nose or tail. The sharper the angle, the worse the distortion. Then, we also have the problem of reflections: shooting toward the sun, a piece of jewelry, a chrome body or ring of the lens in sunlight will surely cause a shiny spot on the exposed film, reflecting from the inside of the window.

These problems can be compensated for and almost eliminated. First of all, the best way to avoid the filteration effect is to shoot with the camera lens as close to the window as possible, without touching the window, for that will surely ruin the picture because of transmitted vibrations. I had never thought about this business of shooting close to the window until Tony Linck explained it one day.

A 50mm lens wide open, has about 3 square inches of surface; if pressed up against a window, it would be shooting through another 3 square inches of glass. Remember, a 50mm lens has an angle of view of 46°; if you move the face of the lens back a mere two inches from

One of the best airplanes for taking aerial photos, the Piper Lance/Cherokee Six types. From the back seat one has a clear view of the ground and other aircraft without the photo plane's wing showing in the picture.

the window, the light going through the aperture comes through almost *ten* square inches of window! From six inches the circle of view is slightly more than 33 square inches and from a foot away the light has to come through 95 square inches. When you pull the camera back two feet, you will shoot through 380 square inches of plexi, the equivalent of six normal sized window panes. The cumulative effect of dirt, scratches and aberrations on that area of glass is compressed on the tiny 35mm negative. More than 90% of that problem can be eliminated simply by taking the picture six inches, or less, from the inside surface of the window.

Scratches on the outside surfaces of plexi can be filled in by some special care of the windows. First, they must be washed inside and out with pure soap, never with ammonia base or any spray window cleaners of the type to clean the mirrors in the bathroom at home, for they will soon ruin the plexi by softening it. The best way to wash the windows is by hand, using Ivory Soap and a lot of water, then rubbing dry with a clean, soft, lint-free cloth (we use old towels for the purpose). Once they are clean of oil, dust, dirt, and bird guano, use a hard wax (any high quality automobile wax will do) and buff gently by hand, using another clean cloth. This treatment has two effects: it fills in the tiny nicks, scratches and surface imperfections and it keeps the windshield clear when flying through rain showers; the rain just zips right off the smooth surface.

Once the plexi has been hard-waxed, use a light type of airplane window cleaner before every flight. Just apply it, rub it around with a light touch and wipe it off after it has dried to a light haze.

Try always to shoot straight through the plexi, at 90° from the plane of the window, which will eliminate just about all the distortions. Of course, you cannot do this through the windshield because of its sweep-back, but, to tell you the truth, it has never seemed to matter much to us, as long as we shoot from eye level and avoid the distortions around the extreme edges.

As for internal reflections from the lens ring, and the camera body, another trick Linck showed me was to wrap the camera with

An almost ideal airplane for air-to-ground photos at low levels, the Piper Cub. Not only is it quiet at low power settings, hence unobtrusive, the entire right side opens up (the window swings up against the wing and the door is hinged at the bottom, and both can be opened in flight) thereby avoiding shooting through plexiglass. Note that objects in the background stand out sharply. Photo taken at 1,000 feet with an 85mm lens on a cloudy-bright day.

black cloth (and to wear dark colored clothing) when shooting up sun, and to take as many of the pictures as possible cross-sun or down sun. Cross-sun is best, because it produces better modelling of objects on the ground.

GO WITH WHAT YOU HAVE

The best aerial photographers have no real preference for high wing over low wing, and can use either style to produce photographs that seem to be bird's eye views without the intercession of an aircraft. Both Jim Yarnell and Tony Linck use low wing airplanes and can produce results without showing a wing or empennage in the picture, which I am sure has great attraction for their clients.

But, over the years, as we have taken pictures, we have not tried to avoid having part of our camera platform show in the picture; on the contrary, we try to have some part show whenever possible. Then, years later, when the image is projected on a screen, it is amazing how the details of that flight flood back into one's consciousness; we remember the plane, who was on board, where we came from and where we were going. As far as I am concerned, that is what aerial photography is all about.

Chapter 11
How High Is Up?

Since the purpose of our taking pictures is to preserve memories, not to plot bombing runs, it follows that they may be taken at any altitude, from the ground up. However, the closer to the ground, the less area you will capture on film and the higher you fly, the greater the scope of the view, but detail is lost. This is not all bad.

If you use a 50mm, "normal" lens, what you see with your naked eye while moseying along the airways towards a clearly defined area such as Cape Cod, Manhattan Island, or New Providence Island in the Bahamas, will be just about what will come up on the subsequently projected slide or on an enlargement of the color negative. Such pictures capture the sweep of an area, the flavor of flying, but details of objects on the ground will not show. If you want to obtain indentifiable pictures of houses, forts, resorts or of people on a beach, you will have to fly lower, or use a telephoto lens to bring the objects optically closer. Both solutions have their limitations.

Federal Aviation Regulations, which have the force of law and impose fines and other sanctions for violations, provide that aircraft must be flown higher than 1,000 feet above the tallest structure within a lateral distance of 2,000 feet and that the lowest legal altitude for flying over open country is 500 feet. The lateral restriction means, for example, that you cannot legally fly at wave height along a bikini-strewn beach, and I must observe that you can never tell who might be on that beach, jotting down your numbers as you sweep by. A modified buzz job can easily become a fuzz job, with the FAA enforcement group paying you some unwanted attention.

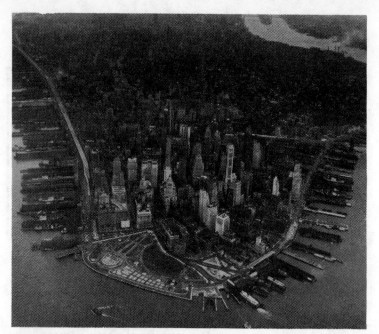

Lower Manhattan Island from 5,000 feet, using a 50mm lens. Note the smoke blowing off the Con Edison stacks in the upper right corner, indicating a cold front passage, hence the unusual clarity of the local atmosphere.

From altitudes as high as 1,000 feet, many details on the ground show up clearly, so that pictures of one's own neighborhood can be taken quite legally and adequately for most purposes. An 80mm lens will help to create the effect of lower flight, an altitude of 500 feet or so, as a pair of 1½ or 2 power opera glasses would do, and by using a 135mm lens, which has about the power of a pair of 3.5 × 50 binoculars, you can stay at 1,000 feet and take pictures of your own backyard.

However, taking pictures while circling at 1,000 feet is really a two-man (or two-person) proposition, one to fly the airplane and the other to take the pictures, and the one flying the airplane should be a well-seasoned pilot. Remember, when the angle of bank increases and the turn is tighter, the stall speed of the wing goes up. You may be sitting there, solid at 120 mph in a 30° bank and the pilot in an effort to get a wing out of the way or to produce a clear shot steepens the turn and pulls up a bit and Zowie!, you are in an over-the-top spin. It is worse if you are trying to fly the airplane and take the picture at the same time, for it is a ready-made trap, just like looking over your shoulder trying to steepen a bank to cure a bad turn onto final approach, where most stall-spin accidents happen. If you make a run

just off to the side of the target, then put a wing down in a 30° bank and quickly snap a picture or two, pointing-and-shooting, you can get some pictures, but they may not be of very good quality; in fact you may wind up with pictures of someone else's backyard and miss your own altogether. I used to have quite a collection of those but finally threw them out.

LONG LENSES

The longer lenses work out much better, except that because they have such narrow fields of view, it is easier to miss the target than when using the 50mm lens with its 46° angle of view. When the longer lenses are used, two people are definitely needed in the airplane, because the odds are that you will be flying somewhat higher and that is where the traffic becomes a factor. Someone has to fly and *look* for other airplanes and the photographer can be free to concentrate on taking the picture.

Flying over the United States, you can see frequent evidences of early civilizations. This is a black and white reproduction of a color photograph taken by Tony Linck of an Indian burial mound in Ohio. Taken from a low altitude late on a springtime afternoon, the modelling of the snake-shaped mound is clearly seen through the trees, just coming into bloom. Later in the summer, when the leaves are out, or when the sun is high in the sky, the sinuous mound is almost invisible from the sky. Shot at 500 feet, 50mm lens on a Canon SLR, using Kodachrome 64. (Tony Linck photo)

Another Indian burial mound in Ohio, photographed from 3,000 feet. The circular mound (foreground) and the hexagonal-shaped mound (background) are connected and a complete golf course has been laid out so as not to disturb them. You can see the left wingtip of Tony Linck's Mooney in the lower left corner of the picture. (Tony Linck photo)

The longer the lens, the greater the magnification, hence the greater the effect of vibrations due to engine and propeller movements, which in turn may mean shooting at faster shutter speeds. For these reasons, it seems to me that the best long lenses for air to ground work are the 80mm (medium long) to the 135mm size lenses, once the decision has been made to supplement the normal lens. Both of these lenses will produce sharp pictures whereas the moment you edge into higher magnifications, the chances of vibration-affected pictures grow.

It is possible to fly low, down to 500 feet over cities and towns, legally; professional photographers do it regularly by making requests for waivers of the height regulations to the local General Aviation District Office (GADO), as do other special airspace users, such as banner towers. It requires a certain amount of paperwork, consultations with FAA types and showing justification for granting the waiver of the regulations which are, after all, created for the safety of the public. Most GADOs are loath to grant waivers to any but Commercial certificated pilots, as might be expected. It really

does not matter, since you can get excellent results from legal altitudes anyhow.

I always recommend that everyone take pictures of his home community—including his home airport—at regular intervals, say, every six months or a year, at most. A series of photos from overhead can be most interesting over a spread of years, for changes can be clearly seen in such a sequence, particularly when taken from the same angle and altitude. In our files are photos of our homes over the years, in Philadelphia, Ocean City, N.J., and Washington, D. C., some of which were taken after we had moved on. We also have a chronological series of the old Flying W Ranch, from the time it was a

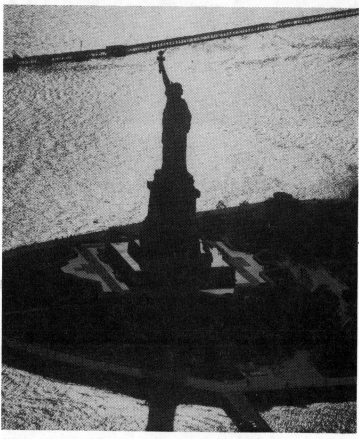

What is wrong with this picture? A tremendously dramatic aerial photo of the Statue of Liberty, backlighted by a later summer sun, is ruined by the bridge cutting across the top of the picture. If the photo plane had been 100 feet higher, the bridge could have been cropped out and the picture saved. Even old pros like Tony Linck make a bad one once in a while. (Tony Linck photo)

Another example of backlighting for effect: this time it worked. The photo was taken from 1,000 feet over the New York borough of Williamsburg down the East River. In the upper middle are the Manhattan Bridge and the Brooklyn Bridge, then the Statue of Liberty on its own island and beyond that, New Jersey's shoreline. Canon camera; 50mm lens; orange filter; Panchromatic film. (Tony Linck photo)

fallow farm until it was a beehive of general aviation activity with 200 based airplanes and thousands of movements every nice weekend. The camera has captured changes that we have frequently forgotten: empty lots have sprouted new homes, old landmarks have been razed to be replaced by new structures, new streets run across what used to be open fields and old streets have been removed from city plans so that shopping malls and centers could be built.

Most people who live along the coastline are aware that the contours and dimensions of the beaches change regularly due to alluvial currents, but few have any concept of the extent of accretion and erosion, or of what happens to the sand. From the air, the movements can be seen: how beaches are built up as offshore sand bars are driven by wind and wave to form broad strands which were narrow strips and how sandy beaches have been carved out to form sand banks and shoals a year or two later. We have photos of the shoreline at Ocean City, N. J. over a 20-year period showing the changes that have moved the surf line in and out for several hundred yards repeatedly. When the light is good and the sea is smooth, an

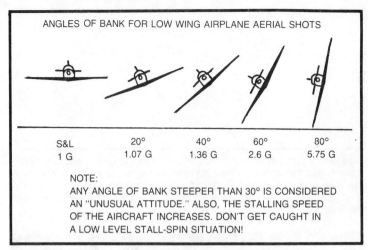

ANGLES OF BANK FOR LOW WING AIRPLANE AERIAL SHOTS

S&L	20°	40°	60°	80°
1 G	1.07 G	1.36 G	2.6 G	5.75 G

NOTE:
ANY ANGLE OF BANK STEEPER THAN 30° IS CONSIDERED
AN "UNUSUAL ATTITUDE." ALSO, THE STALLING SPEED
OF THE AIRCRAFT INCREASES. DON'T GET CAUGHT IN
A LOW LEVEL STALL-SPIN SITUATION!

Be careful not to over-bank when circling a ground target!

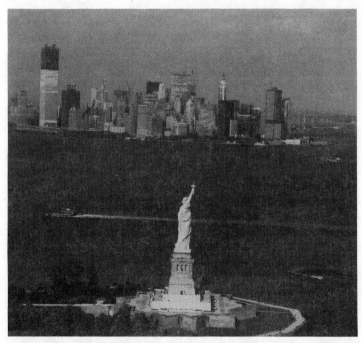

An interesting study in perspective and modelling. This photograph was taken towards the Northeast from 600 feet, using an orange filter on Panchromatic film. Although the clouds are not well defined, the Statue of Liberty's robes and windows in building over two miles away can be seen clearly and individuals can be ascertained in the park at the base of the statue. Canon, with 50mm lens at 1/500th and f/8. (Tony Linck photo)

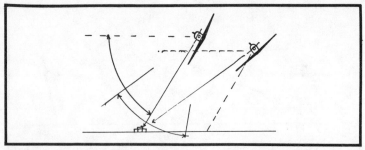

Frequently a better photo will result if you stay out a ways and do not bank too steeply. Note that the field of view of the 50mm camera on the lower airplane in the illustration will include both the object on the ground and the horizon, thus giving the photo more sweep. Using a SLR, one can see exactly what will be in the final picture.

Sequential pictures of the Tappan Zee Bridge being built across the Hudson River, north of New York. Pictures of the same area, taken over a period of time, show many changes.

airman can look right down into the water and see the sand forma-
tions below the surface—and so can his camera.

The best altitude for showing specific details as these is about
1,000 feet, using the normal lens. If air shots are taken from much
lower than that, they become too specific, too restricted in their
scope; if higher than 1,500 feet, shooting downward at an angle of
45° to 60° below the horizon, much detail is lost. Sometimes details

Construction on the Tappan Zee Bridge nearing completion.

Fort Fumble! The Pentagon, in Washington, D.C., taken from 2,000 feet with a normal lens. This is an excellent picture of the structure and the marina with the Potomac River beyond, but a wide angle lens would have shown the Washington Monument, the Lincoln Memorial and the Capitol as well, which would have made a much more interesting picture for most viewers. (Tony Linck photo)

make the picture: flying down the East Coast, along the seaboard between Myrtle Beach and Miami, the scenery varies from wetlands carved into Daliesque landscapes by streams and ponds and the straight lines of the Intracoastal Waterway, all of which are eye catching, especially to anyone who lives in a highly populated urban area. From a mile, or two miles above, the scenery looks almost desolate, uninhabited, forbidding. From 1,000 feet, it is a different world: many of those remote little islands have homes, some of them pretty sizeable, some little more than shacks, but making it clear that people live there in splendid isolation and make excellent photo subjects.

As you pass down the line past Hilton Head and Sea Island and Jekyll and Amelia, resorts begin to show up, and golf courses and palatial homes. Fly too high, and you miss those picture opportunities, which add flavor to the photo story of your trip. From 1,000 feet, they are all yours.

Of course, flying at low altitude, where the angle of view will show the immediate area of the target but not the full sweep of the

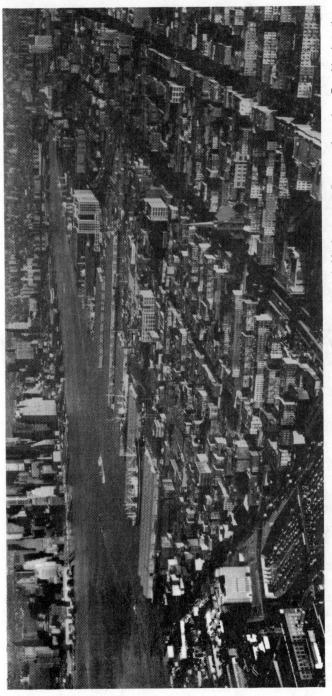

This is a commercial contract photo taken by Tony Linck from overhead Brooklyn towards Manhattan to tell a story: how close Brooklyn is to the island because of the new vehicular tunnel (note the tunnel entrance at the lower left). It was taken shortly after sunrise, immediately on the heels of a cold front that had washed all the air pollution away so that the towers of Manhattan stand out clearly five miles away. Smog is just beginning to build up around the Empire State Building area. (Tony Linck photo)

setting in which it lies, is not always photographically helpful, particularly when flying over a strange region. Every once in a while, we will flash a picture on the screen of a lonely home on an island, or an unusual construction, such as a ruined old plantation house, and wonder where we took it, since no identifying features are observable in the picture. It helps to have a filing system so that consecutive

On the way home from the Brooklyn assignment Tony was scooting up the East River at 500 feet to remain below the La Guardia airport traffic when he saw this sensational scene of the United Nations Building reflecting the early morning sunshine. This is a real "grab shot," taken only because he had his camera at the ready. Both shots with 35mm Canon, using 50mm lens, no filter.

A sweeping shot of rolling farmland in Eastern Pennsylvania, taken with a 35mm focal length lens. Note that the structures in the lower left corner are almost directly below, yet the top of the picture is at the horizon. Compare this with the photo of the Pentagon, taken from the same altitude.

pictures on any roll of film can be immediately identified, as long as ten years later.

So, to the question, "How High Is Up?", the best answer is, as high as you can see the ground and take a picture of it. When you use the normal lens, you can be reasonably sure that, to borrow a line from Flip Wilson, what you see is what you're gonna get.

Chapter 12
Air To Air Photography

Every pilot who has been exposed to those gorgeous full color photographs of aircraft in flight, as seen in aviation magazines and the advertising brochures of all aircraft manufacturing companies, eventually hankers to have such a picture of his own airplane, with himself at the controls. It is highly likely, therefore, when you become known as a successful airborne shutterbug, that at least one of your airplane-owning friends will try to importune you to aviate in formation with him some fine day, so you can immortalize him in living color. My best advice is: Don't do it! It is *really* dangerous.

If your friend is serious about having such a photo to hang in his home or office, he should hire a professional aerial photographer to do the job—and pay him for it. The odds are very long against the pictures you will take being satisfactory. Not only will you bear the cost of taking the pictures, which includes the cost of operating your airplane as a "favor" for a friend (many of whom blandly suggest that they will be willing to pay for the film), you will also be subjecting yourself to what the law calls an unreasonable risk of harm. Flying airplanes close together is far more dangerous than any weekend (and many professional) pilots realize. It looks easy when experts do it, but it takes a great deal of tutelege under first-rate instructors and considerable practice. Air to air shooting is a three or four man job, at least three.

My teacher was Tony Linck, highly experienced in the techniques involved and acknowledged to be one of the best in the business, with more than a hundred front-cover photographs on

leading aviation magazines to his credit. In addition, Tony also for many years produced the advertising brochure photos for both Piper and Mooney aircraft companies, so when he speaks, I listen closely, with profound respect.

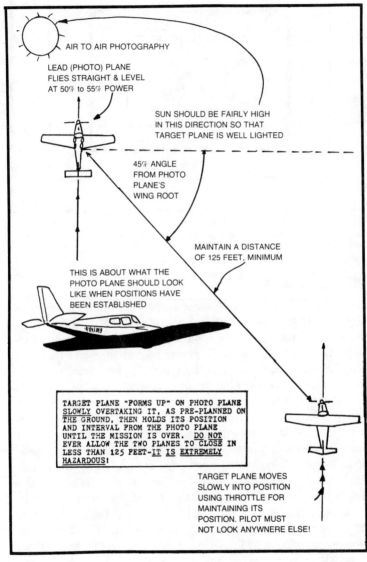

Target plane "forms up" on photo plane slowly overtaking it, as pre-planned on the ground, then holds its position and interval from the photo plane until the mission is over. Do not ever allow the two planes to close in less than 125 feet—it is extremely hazardous!

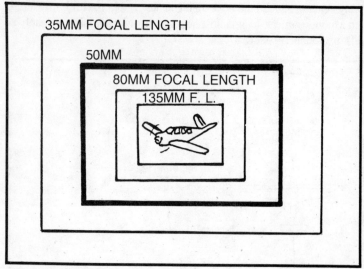

The advantage of telescopic lenses for air-to-air shots. A zoom lens is particularly handy, for the target can be picked up with the wide angle focal length and then can be "zoomed" up close without bringing the airplanes any closer together.

MISSION PLANNING

First of all, Tony will no take pictures of another airplane unless he knows its pilot and especially his level of skill at close formation flying. Then, no matter how good the guy is, nor how many times they have worked together, Tony always goes through a complete briefing session on the ground, to explain what he is going to do and exactly what he expects the target plane pilot to do.

Part of his pre-flight planning involves taxying both planes over to a quiet location on the airport and parking them in the position and at the distance he wants both to fly. With the pilot of the target ship seated in the cockpit, he can see how large the photo ship will appear when they are flying, so he won't edge in too closely. Then Tony climbs into his own plane, a low-wing Mooney, to be certain that the lens he plans to use will be right for the shot. His general rule is not to have the target plane closer than 125 feet, about the distance from home plate to second base, and positioned at 45° off from the junction of the wing and fuselage, which keeps parts of the photo plane out of the photo.

Linck's technique is to have a pilot fly his (photo plane) Mooney straight and level at relatively slow speed, about 120 mph. The photo plane's pilot has two important jobs: hold the plane straight and level

precisely and look out for other air traffic. He is responsible for "clearing the air," since a mid-air collision could ruin the mission.

About straight and level: Few pilots realize how *un*-straight and *un*-level most of us fly, until two airplanes are going the same direction close together and the other plane seems to be on a yo-yo string. The hazard comes when the pilot of the forming-up plane begins to maneuver into position, because, for the first time he can see what small displacements of the controls do to the course of the airplane. If the lead plane seems to be moving away and the chase plane's pilot just puts in a little pressure on the aileron, he will move sideways 50 feet in a second or two. You have to experience this to realize how quickly everything happens; but believe me, it can be scary and non-habit-forming.

Air to air photography by Tony Linck for a Mooney aircraft brochure. Three aircraft of different performance characteristics have formed up on Linck's Mooney in an echelon left formation, an exacting, precise bit of flying. Note the light value vatioations of the target aircraft, the bright white clouds and the earth in cloud shadows. Formed up at the 45 degree angle, no part of the low wing photo plane appears in the photo.

An air-to-air shot to end all air-to-air shots! Somewhere over East Texas, Tony Linck took this photo of a Mooney Mark 21 with its engine shut down. Note that the propeller is stopped—and a sailplane formed up on his own Mooney. An incredible aerial photograph.

With the photo plane flying straight and level, and its pilot scanning the skies endlessly, the chase, or target plane begins to come up from behind slowly overtaking it, trying to position itself out there 125 feet between the angle of the wing and fuselage. It is a very delicate maneuver; if the chase plane has only a few extra knots of airspeed, it will just slide right on past, which re-creates a serious problem: finding the photo plane again in the vastness of the sky. I have lost count of the times I have spent as long as 45 minutes making a rendezvous with my sons when we were going to fly a loose

formation on a long trip, although we were in clear skies and talking to each other over the same visual or radio fix, trying to form up.

Anyhow, the chase plane pilot has to exert precise speed control as he approaches the "photo window;" keeping the airspeed of the lead ship at a leisurely pace gives the chase plane pilot lots of throttle to play with to make speed adjustments; *tiny* throttle adjustments are the key. Tony always makes certain that the target plane pilot will make lateral—sideways—adjustments with rudder pressures only, *never* any aileron (stick or wheel) movements that will put a wing down at all, which will result in one of those sidewise swoops.

The eyes of the target plane's pilot must be riveted on the photo plane every second, so that he can react instantaneously to any movement that changes the interval between the two planes. He cannot look away for a moment. This is why it is wise to have another pilot along in the chase plane, just to keep sweeping the sky with his eyes; it helps the nervous condition of the target plane's pilot to have someone there advising him that they are not about to have their day ruined by another airplane suddenly appearing in the vicinity.

I emphasize that no one should ever try to fly closely to another airplane, whether by prearrangement or not, unless he has first had some instruction in that specialized type of flying.

With that warning, let me say that if you *do* intend to take air-to-air shots of a friend's airplane, use a telephoto lens, somewhere between 80mm and 135mm, which is about as long a lens as can be consistently used with success because of the vibration problems we talked about before. I have gone as high as the 200mm lenses several times, but out of a roll of 36 exposures, perhaps two or three, shot at high speeds (1/1000th of a second) have been sharp enough to enlarge. Brief both pilots—by this time, I hope you realize that you cannot fly the lead ship and take pictures and be safe!—and be sure that the planes never come closer than 125 feet—maybe 150 feet would be better—and shoot up as many pictures as you can, bracketing every shot, one stop over and one stop under the best indicated exposure on the meter.

If you are lucky, you may wind up with a couple of good pictures. But, when you figure the cost, it may prove to be wiser to call a professional like Tony Linck and have the job done right.

Chapter 13

Take Care Of Your Camera

If you are going to invest a respectable amount of money in a camera for the purpose of preserving memories of flights to far off places, or of your own home area, it behooves you to keep the camera in top operating condition at all times, clean, equipped with fresh batteries (if it has a built-in light meter or coupled shutter and aperture system) and ready to go whenever you do. It always upsets me to see a camera—any camera—left sitting out in the open where it will collect dust and dirt and especially in salt air environments, where the danger of corrosion damage is especially high. Your camera deserves better treatment than that.

Modern single lens reflex cameras are not necessarily as delicate as Waterford Crystal, but they are not as solid as a brick, either. Their working parts are full of small steel springs, sliding parts, as in the aperture-setting diaphragm assembly, little gear trains, internal mirrors, and of course, the multi-element lens systems, or lenses, if you have interchangeable glassware. Because the lens assemblies protrude from the body of the camera, they and their mountings are extremely vulnerable to bangs and knocks; when you realize that optical accuracy requires precision computed in micro-millimeters—thousandths of a millimeter—it follows that it does not take much of a blow to put a camera out of whack. The worst part is that one frequently does not know that the camera is not functioning properly until the processed film is returned by the processing lab, long after the trip is over, when it is too late.

THE ULTIMATE MAINTENANCE PROGRAM

Several times in these remarks, I have alluded to the unsurpassable photographs which appear in the *National Geographic Magazine*, almost all of which are shot with 35mm cameras. Let me tell you how they maintain their photographic equipment.

To start with, all of the *Geographic's* cameras and lens systems are maintained in an air conditioned, constant-temperature vault when it is not being used in the field. When a staff photographer is assigned to a story, he logs out what he needs, including two or three camera bodies and the entire array of lenses from the fisheyes to the big bertha telephotos, flash attachments, motor drives, and a wheelbarrow load of color film.

When the assignment has been completed, all of the equipment is returned to the society's own camera department, where it is disassembled, thoroughly inspected and rebuilt to as-new condition, after which it is again stored in the camera department's vault, approved for use for a new assignment.

WHAT YOU CAN DO

Few of us will treat our cameras as the *National Geographic Society* does, but we can at least take care of the camera by protecting it when it is not actually being used.

The first step is to keep it in a case built to hold the camera body and its normal lens. Many of the bumps and jolts that hurt equipment come when a camera is being handled normally in transit, being picked up, or put down or swinging from a neck strap. Enclosing the body and lens in a leather container will prevent much unnecessary damage.

If you plan to acquire some additional lenses, they, too, should be encased in their own padded lens carriers which will protect them from dust and dirt particles which are everywhere, including the cabin of an airplane.

CARRYING CASES

For moving from one location to another, it soon becomes evident that what is needed to carry a camera, extra lenses, cleaning equipment, a film supply, extra batteries, a back-up exposure meter and assorted gadgets such as lens filters, flash attachments, etc., will be a carryall case, where everything will be kept in one place.

For years I used a "gadget bag" which looked like a large tote bag with a shoulder strap, known in military parlance as a musette bag—as a matter of fact, it was a war-surplus musette bag—but as

my array of equipment grew, I found that it was (a) not large enough and (b) that the objects carried in it were banging against each other. The answer was to buy a padded, compartmented photographer's case, so that each item rested in its own foam rubber nest, protected from shocks and direct blows. These cases look like what are called dispatch cases (sometimes referred to as "Madison Avenue lunch boxes"); they come in various colors, in leather, simulated leather or aluminum and the good ones are both waterproof and airtight, as well as being padded. In use, I keep my camera case on the back seat, closed but unlatched, so that I can reach back and pick up the camera in a couple of seconds, cock the shutter and shoot a picture. Of course, the focus, shutter speed and aperture have all been pre-set and taped so they won't change accidentally. With my camera, a Nikkormat, lenses can be changed in less than ten seconds from 50mm to 135mm, or whatever; I believe that a zoom lens in the 37mm to 105mm focal lengths, or thereabouts, is much more flexible and am going to move that way (as soon as I pay for my new DME—pilots will understand).

When I am back, safe and sound and on the ground, I latch the case and carry it with me. No one handles my camera case *but* me. Foam rubber is good, but preventive care is better.

IT'S THE LITTLE THINGS THAT HURT

Dramatic injuries, such as dropping a camera out of the airplane or down a stairwell, are possible, but not really usual. The major cause of damage to cameras is not hard knocks and bangs, as most people suppose. The principal culprit is almost invisible to the human eye, except when a shaft of sunlight pierces a dark room: dust. Dust, dirt, salt in the air (as at the seashore, where we live) and especially sand, can ruin the delicate mechanisms and the microsopic lens coatings in short order. Fine, blowing sand can put a camera hors de combat as quickly as dropping it off a pyramid. I know. Both of those things have happened to me.

The close tolerance of the mechanisms in our 35mm cameras and their accessories require smooth operation of all moving parts and a few grains of sand can do as much harm as dropping the proverbial monkey wrench into a large piece of machinery. Improper cleaning techniques can scar and deface the delicate lens coatings which are so important in modern optics.

CLEANING A CAMERA

It is important to keep your camera clean, almost immaculate, if it is to produce uniformly good photographs time after time. It is not

difficult if the camera has been protected in a case, nor does it require much in the way of equipment: a small delicate brush, usually of camel's hair, an air syringe, or "puffer" and some lens tissue, all of which are obtainable at any good camera shop. It also pays to have some pieces of soft, lint-free cloth, about four inches square stashed away in the carrying case. Although Kleenix and other makes of hand tissue may be used in a pinch, they tend to shed lint which sticks to the camera and lens and must be removed; the lint-free lens tissues made especially for photography are much preferable. In any event any residual lint can be blown off with the puffer.

Each time, before you carry the camera to the airport, open it (assuming that is is unloaded) and puff out the interior, using the syringe, not your breath; the moisture of your breath will condense inside the camera and can cause corrosion problems. When you puff it with the puffer, hold the camera so that the dislodged dust, dirt, etc., will fall out of the camera, not back into it. Then wipe it down gently with the lint-free cloth, load it and be ready to go.

CLEANING THE LENS

The only part of the lens you can clean is the front surface and possibly the rear surface, if you remove the assembly from the camera body to expose it. It is somewhat harder to reach in through the back of the empty camera and clean the inside surface of the lens, but it can be done, of course.

Again, the camel's hair brush and puffer are the primary tools, along with the photographic quality lens tissues which are needed if a greasy smear, as from a fingerprint, is on the surface of the lens. Do *not* ever use silicone-treated eyeglass cleaning tissues on the coated lenses of your camera! The silicone residue can have undesirable results on the carefully designed optics, of which the lens coating is an integral part.

Most cleaning operations on a day-to-day basis will involve only the outer surface of the lens, because it is always exposed to the dust and dirt particles floating in the air when it is being actually used to take a picture. Most photographers keep the lens covered with a snap-on lens cover to protect it. In addition, most of us have learned that the clear-appearing ultraviolet or the skylight filter can be left screwed into the front of the actual lens all of the time, which gives it better protection. Of course, the protective filter has to be cleaned, instead of the actual lens.

Most of the time, a few passes with the camel's hair brush and some puffs from the syringe will be enough. Use light circular passes, starting from the center of the lens and working outwards,

holding the camera so that the dislodged particles will fall away from the lens, not back upon it. If this does not do the job, as when a finger smudge is on the lens, the light film of grease can be removed by a piece of lens cleaning tissue which comes in small packets, like book matches. Tear off a sheet, fold it carefully a couple of times so that the torn edge can be used as a brush and dab at the lens with this frizzly end, working from the center outwards in a series of swirly motions until the oil is picked up by the absorbent tissue. Do not press hard; the touch should be like that of a butterfly's wing. Never try to "polish" a lens, you might injure the delicate coating. Just take your time and be delicate and gentle and the lens will come up clear and sparkling.

It is not necessary to have your camera taken apart and completely rebuilt, as done by the *Geographic* photo lab. Unless it is really damaged by being exposed to fine, blowing sand, or a heavy dust storm, or salt water contact, a modern 35mm SLR will give years of pleasure and use, both on the ground and in the air, if you merely take a few precautions.

Chapter 14

File—Never Forget!

If you take one or two long vacation trips a year and shoot films by the dozen on each, it does not take long to accumulate a thousand pictures, either prints or slide transparencies. If you shoot additional pictures on weekend forays in addition to those long-legged vacation jaunts, you can double that output. Believe me, they mount up to the point where your experiences captured on film can be confusing. The answer is to begin organizing your photographs right at the beginning.

There are several ways to organize film records. You can do it by subject matter, or by geography, or by people, or by individual trips, or by date. No matter which system you decide on, use it consistently. Most important, do not simply pick up the pictures from the processor, look at them, and drop them into a drawer somewhere. After a few years, you won't have any idea of what is where and will be unable to retrieve a picture that you know is somewhere in your possession. Retrieval is the secret of maintaining office records and photographic records.

I started off all wrong and screwed up my own photo records from the start and have been trying to unscrew them ever since. At first I had several categories, which I lumped together: Family; Friends; Social occasions (birthdays, etc.); Sailing shots; Hunting and Fishing; Air shots; Bahamas; Cross country trips; Smith homes; Smith homes, as seen from the Air; Dogs; Airplanes...the list went on and on.

My second mistake was that when I picked up my developed film (we use slide transparencies most of the time), I would buy a

Every once in a while you will take a picture while flying across-country, then later wonder what it was. This shows farmland erosion caused by heavy rains, as seen from 5,000 feet over the Middle West, using a 50mm lens, no filter.

slide tray to hold them so they could be projected that night. Soon, I had a sizeable collection of slide trays, which led to another problem.

Photo-bugs are also gadgeteers; every time a new type of projector would come to my attention, especially if it seemed to offer some great new improvement for showing slides, I would buy it. Unfortunately, several of the projectors I acquired were not compatible with the slide trays already in hand, which meant getting new, non-interchangeable projection trays. To shrink a long story, I found that I had literally bookcases full of slide-holding projection trays, some that held 25 slides, some that held 50 and some, of the rotary or drum type that held 150, or so. All filled up. Then, when I came back with the latest pile of slides from the lab, I would dump an old tray to make room for the new pictures I wanted to see. I wound up in utter chaos.

My recommendation is that the first thing you do when you get the pictures from the developing lab, is *date them.* Some labs do this for you, at least to show the date they were processed. I recommend that you date them with the date they were taken, the date of the trip, or whatever the occasion happened to be.

The next step is to avoid the trap of putting the slides in a projection tray and leaving them there. You may have a dozen or so trays on hand, but when you are through looking at them on the screen, take the slides out of the tray and place them chronologically in a file for permanent storage. Slides are consecutively numbered when you get them back, but the numbers may not be truly consecu-

tive in the file, because we all blow a few shots and it makes sense to toss the bad one out. But if they are filed by date, you can keep a master record of the trips or photo missions and it is amazing how you can say to yourself several years later, "Oh yeah, we were in the Bahamas, (or Las Vegas, or Palm Springs, of Mackinack Island, or Florida, or Memphis) in 1977, about May," and go right to the series of pictures you want. To a lesser degree, this also works with color negative prints and negatives, which require dual filing systems, which is another reason I prefer color slides for most of my air shots. Slowly, I am going back over some 20 years of color slides and putting them in order, which gives me something to do on those cold winter evenings, instead of watching television.

FILE SYSTEMS

All photographic shops carry commercial slide files which will hold a couple of hundred slides at a time. I have been using such filing boxes for the products of the last few months of shooting, but not for permanent storage. What I use for long term storage is a series of wooden boxes, each of which will hold 1,400 slides in five rows of 280 each, by dates, beginning in 1955. I will have eight of them filled pretty soon—if we have another long, cold winter. My main problem is that, as I review the slides, they awaken so many memories that I break out the screen and projector and re-live those precious moments all over again. Marianne and I spent most of last February watching our kids grow up again, from the time they were flying with me as toddlers until they were grown men, all pilots themselves. We saw, and remembered old friends, now gone, with whom we had fun in days gone by. We re-lived our first halting, possibly inept long cross-country flights to Florida and the Bahamas and saw what our first view of Miami's Gold Coast looked like *before* the Diplomat and Eden Roc Hotels were built. We went back in time to our first visits to Las Vegas, when it was still a small all-night town in the desert, and the wide expanse of the United States on our early Coast to Coast trips in our own light plane. Memories become alive when those old pictures are shining from the screen in our living room. Our hearts are warmed and our spirits soar, when once again the magic of color photography strips away the years and our hearts are young and gay. When towering cumulus clouds stand like battlements in the sky over the nose of our Comanche, or our Apache or our Cherokee Six, we can prove that, although we see them again while sitting in the warmth of our home, there were times when we really did slip the surly bonds of earth and I have put out *my* hand and touched the face of God.

Index